Landsca Drawing

with Pencil—

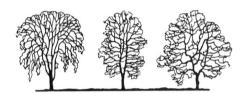

Frank M. Rines

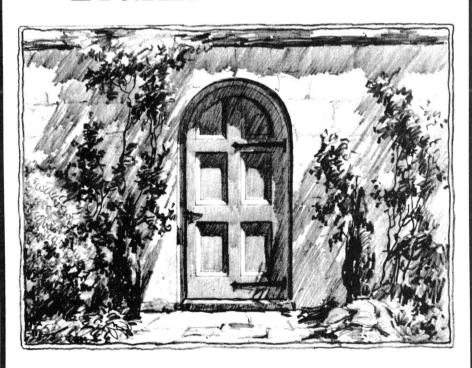

Sterling Publishing Co., Inc. New York

Library of Congress Cataloging-in-Publication Data

Rines, Frank M.

Landscape drawing with a pencil / Frank M. Rines.
p. cm.
Originally published: London: Oak Tree Press; New York:
Sterling Pub. Co., 1964.
Includes index.
ISBN 0-8069-8546-1
1. Landscape drawing—Technique.
2. Pencil drawing—Technique.
I. Title.
[NC795.R56 1992]
743'.836—dc20
91–43733
CIP

10 9 8 7 6 5 4 3 2

Published by Sterling Publishing Company, Inc. 387 Park Avenue South, New York, N.Y. 10016 © 1964, 1991 by Sterling Publishing Company A combined volume of Frank M. Rines' work including Paper Drawing © 1940 by Bridgman Publishers, Inc. Drawing in Lead Pencil © 1929 by Bridgman Publishers, Inc. Tree Drawing © 1936 by Bridgman Publishers, Inc. Distributed in Canada by Sterling Publishing % Canadian Manda Group, P.O. Box 920, Station U Toronto, Ontario, Canada M8Z 5P9 Distributed in Great Britain and Europe by Cassell PLC Villiers House, 41/47 Strand, London WC2N 5JE, England Distributed in Australia by Capricorn Link Ltd. P.O. Box 665, Lane Cove, NSW 2066 Manufactured in the United States of America All rights reserved

Sterling ISBN 0-8069-8546-1

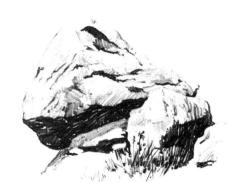

CONTENTS

Introduction	5	Pastoral Scene	71
Drawing in Lead Pencil	7	Bath Place, Oxford	73
Focal Point	16	Punting on the Cherwell	75
Pencil Texture	18	Lane in Woodstock	77
Steps in Pencil Rendering	20	Fisher Row and Oxford Castle	79
Sketching	22	Bridge at Godstow	81
Completing the Sketch	24	Ruins of an Old Nursery	83
Perspective	26	Thatched Cottage, Garsington	85
Interesting Textures	28	Grange Gate, Milton, England	87
Contrast of Light and Shade	31	The Old and the New	89
Tree Construction	33	Willows	91
Sunlight and Shadow	51	Old Mill in Londonderry, Vermont	93
Rocks and Willows	53	Old Chase Homestead	95
Silver Poplars	55	Oliver Cromwell's Mill	97
Vine Covered Cottage	57	Chiddingstone Cottage	99
Trout Brook	59	Cottage at Clifton Hampden	101
Edge of the Village	61	Half Timbered Houses at Kent	103
Main Street — U. S.	63	Magdalen Tower, Oxford	105
Covered Bridge	65	Magdalen Tower from the Meadow	107
Covered Bridge, Vermont	67	Fish Wharves, Rockport	109
Country Lane	68	Floral Technique	110
Old Swimming Hole	60		

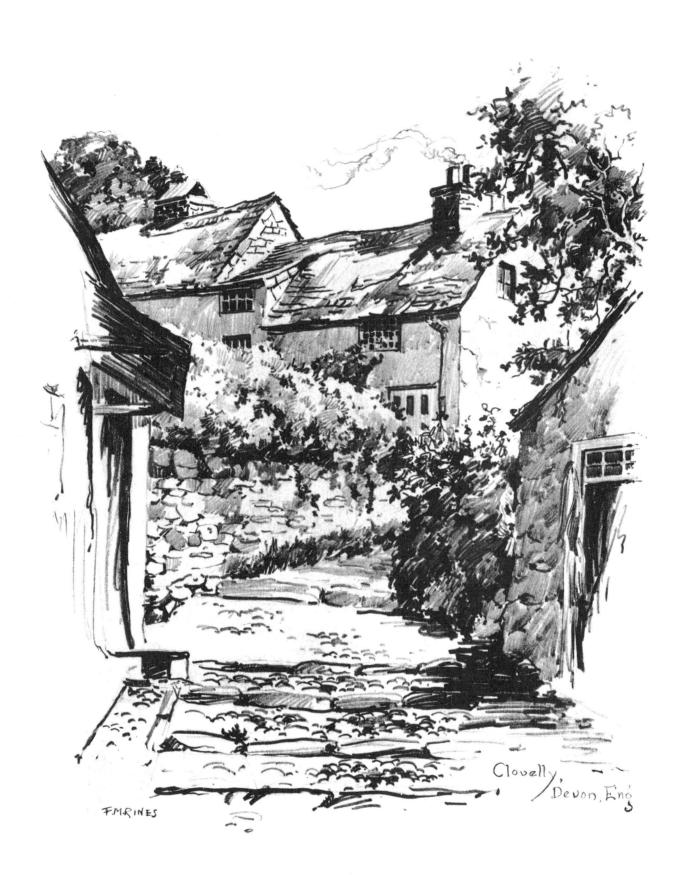

INTRODUCTION

Only recently has the pencil been considered by the laymen, as well as most artists, as anything more than a tool with which to sketch or map out ideas, layouts, etc. That pencils are ideally adapted to carry these ideas further—to carry them to completion in fact, will be obvious to anyone visiting our art galleries, or studying our recent books and periodicals, especially those of an architectural nature.

While closely allied with the other branches of Art, the pencil, like any other medium, necessitates certain methods or tricks in handling, peculiar to itself. A realization of the possibilities and limitations of the pencil is the first, and most important requisite to an understanding and appreciation of pencil work.

The purpose of this book is, not to make a finished "artist" out of everyone who chances to pick it up. Its aim is rather an appeal to those students, who have had some training and experience in drawing with other media—from the cast, we will say, with charcoal—and especially some knowledge of free-hand perspective (concerning which many excellent books are available)—to arouse an interest in the art of pencil technique, especially as it pertains to out-of-door subjects. If others,—those who are interested in art, in all its different aspects—are helped towards a better understanding of such work—then the reader and everyone who works with the pencil has been benefited.

The author does not attempt to establish any hard and fast rules as to technique, nor to imply that the examples shown here are the only way in which the pencil should be used —for one of the beauties of pencil sketching is that there are as many different ways of working as there are persons to attempt it, and each student progressing in this work will gradually develop his or her personal technique, just as each one of us puts more or less of our individual characteristics into our handwriting. This of course is as it should be; otherwise only a limited few artists would be needed to supply the entire demand for work of this nature.

A careful study of the following pages will, it is hoped, however, show how one artist has met and dealt with certain problems. The suggestions, principles, and few rules that follow have all been tried out with different groups of students and individuals. The results, naturally, have varied proportionately with the ability and previous drawing experience of each. In the majority of cases, however, the results have proved satisfactory, not only to the student himself, but also to the instructor.

"Copying" the examples given here is very inadvisable, but a careful study of each drawing is urged. After becoming familiar with the manner of holding the pencil, making the different strokes and the rendering of different materials, etc., as taken up in the first plates, the student is then advised to study carefully the following plates with the aid of the analysis accompanying each, explaining why this was done that way, and that was done this way, and to put himself, as much as possible, in the artist's place, applying his problems, as nearly as he can, to similar ones of his own.

Wherever practical, work directly from nature, but when, as is often the case, this cannot be done, good photographs may be used instead. In the author's experience with many different classes, working from photographs has been found to be very satisfactory, and it is highly recommended.

Constant and continual practice is the only sure way to succeed, in pencil drawing, as in anything else. To create the desire and determination to do this, and to help the student towards an ability to criticize his own work, which will develop step by step with his progress, is the author's wish. Needless to say, constant reference to the drawings reproduced here, as well as to those of other pencil renderers (of which the student should have many good examples) is one of the chief ingredients in the recipe for success.

DRAWING IN LEAD PENCIL

There are four important things to work for when drawing with the pencil. The first is correct drawing, the second, design or composition. Of course, these are needed for successful results in any medium. The third: to be able to leave out all unimportant detail, and the fourth: to obtain contrast, sparkle, and "snap," are the goals for which the embryo pencil artist must strive. The eliminating of all that is not pertinent to the subject, is a stumbling block which retards the progress of every beginner; nevertheless it is an important element of all artwork; for, in spite of the variety of tones which the different grades of drawing pencils will produce, simplicity, so needful in bringing about contrast, prohibits the introduction of any but the essential or dominant features of the subject.

Merely reading this statement will not, perhaps, impress the student; but the fallacy of drawing everything he sees will gradually come to him as he progresses with his work. Therefore, we will dispense with further discussion of the matter at this time, but will bring it forward frequently, clothed in slightly different terms.

Technique is the outstanding point of pencil sketching which makes it so different in character from other media. The way the strokes are made is one of the most potent ways of making the drawing interesting. While the technique, when the sketch is completed, should not be so obvious as to blind the observer to the other qualities, yet the way the strokes are laid on is what constitutes the charm of a pencil sketch. The way in which the drawing is done, or built up, is one of the reasons for using the pencil in the beginning.

As stated in the introduction, it is presupposed that the reader has some knowledge and understanding of the principles of drawing and perspective, but that making finished sketches with the pencil is more or less new to him. Therefore, a certain familiarity with his materials and how to use them, is the logical first step. With this in mind, the following sketches and diagrams have been prepared. A conscientious study of these will bring home many facts, which mere words would fail to do.

It has been said that "a good workman never complains of his tools." Very true; but have you ever noticed that a good workman never needs to complain; that he always has good tools?

One of the most important things with which to start, is a drawing board, unless one intends to do all his work indoors, in which case a drawing or drafting table will do. In any event the wooden surface should not measure less than 14 x 20 inches. The reason for this will appear later. For paper, a smooth surface white Bristol Board of not less than three ply is necessary. This paper, which comes in a sheet 22 x 28 inches in size, may very conveniently be divided into four pieces of 11 x 14 inches each. There are several reasons for emphasizing this particular paper so strongly, one of which is its erasing qualities; no matter how much it is scrubbed, the surface is never impaired. Another equally important reason is its sympathetic response to every pencil stroke; while later on when the student has acquired considerable effi-

ciency in rendering, he may experiment with other papers; it is predicted that he will

never become fully weaned from the Bristol Board, when, by actual test, its value has been proven. All the drawings shown here were made on this paper, on the quarter sheets. The fact that they have been reduced to their present size should be borne in mind when examining the strokes.

The better makes of drawing pencils, of which there are several, come in a series of grades of hardness and softness. They range from 8 H, the hardest, to 6 B, the softest. For our purposes the 2 H, H, F, HB, B, BB, BBB, and BBBB are all that are necessary, but none of these grades should be omitted.

Besides pencils, paper, and board, three kinds of erasers are required; a kneaded, a medium hard, and a piece of Art gum. Something on which to wear down the points of the pencils, after they have been sharpened with either a sharp knife, or a razor blade; a piece of sandpaper, or better still, a "charcoal scratcher," as it is called, and a few tacks or pins complete the equipment and the student is ready to take the first plunge.

This first plunge, and many following it, should consist of practising the different strokes, in order to become thoroughly familiar with the "feel" of the pencil and to get acquainted with its possibilities. Prior to this, however, the pencils should all be cut as shown. Not more than 3/16 of an inch of the lead should project beyond the wood, but this lead should be left its full diameter, and not tapered. When all the pencils have been cut this way they should be held at an angle of about 45 degrees, and, on the sandpaper, worn to a

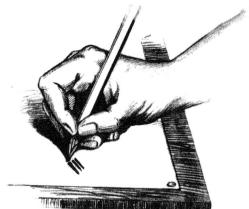

wedge shape, as shown in the illustration. Before attempting to draw with them, run them over a piece of scrap paper once or twice, in order to remove all loose graphite. When this has been done, by holding the pencil as shown in sketch of hand, either the widest of lines (dependent upon the thickness of the lead) can be made, or also, the finest of lines, by turning the pencil so that only the edge touches the paper.

Of all the pencils mentioned, the 2H alone should be cut to a sharp point instead of the wedge shape, and used to lightly sketch in the outline and shadow shapes of the drawing. If these lines are drawn lightly enough, they need not be erased; it is always better to lay in the construction lines lightly.

As a careful examination of the strokes will reveal, they have in all cases been made direct, that is, each stroke has been made in some definite direction, and then left that way; it has not been scumbled, or gone over again. In many cases, each stroke is distinctly separated from the others with a streak of white paper between; again, they have been placed so closely together that they give the appearance of a flat wash, or as if done with a brush. In any event the strokes must be made with decision; that is why plenty of time should be spent on just the practice of making them—short ones, long ones, straight ones, curved ones, separated and close together; before attempting to apply them in an actual composition. When a reasonable amount of efficiency has been achieved in making the strokes themselves, then the rendering of details is next in order. Not only those shown may be tried, but an infinite number of others, as they suggest themselves to the student.

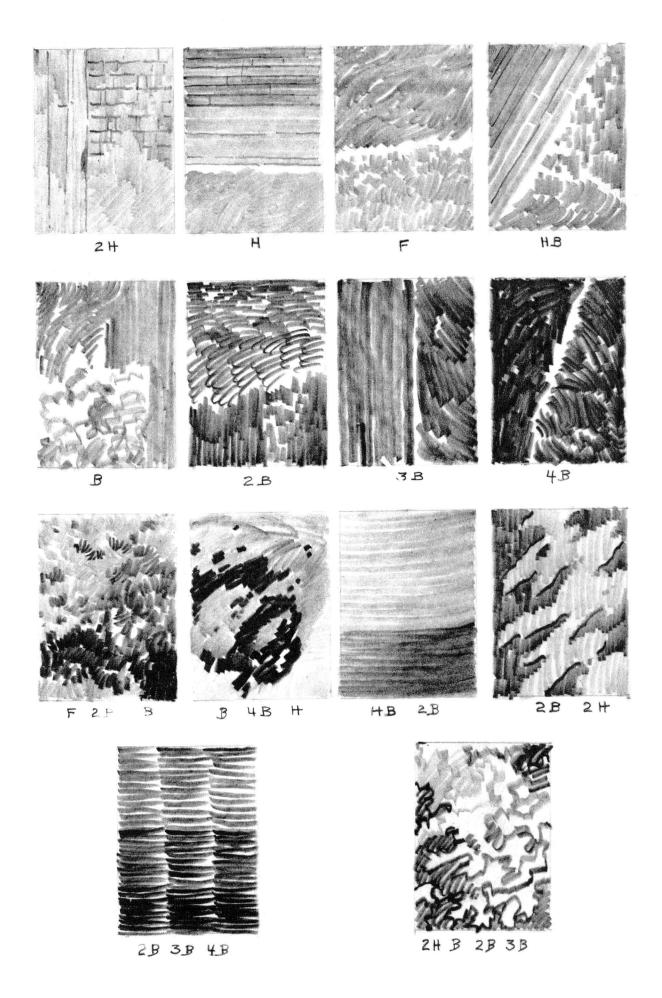

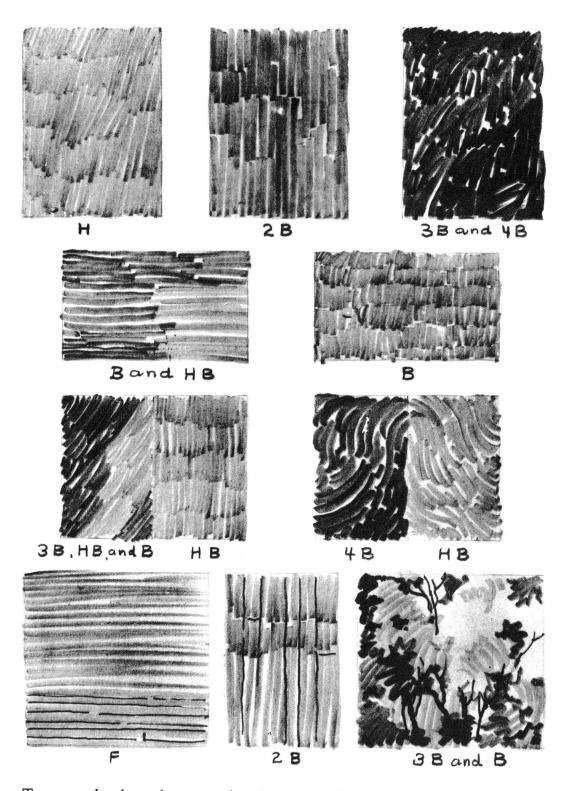

The examples shown here are only a few of an infinite number of strokes and combinations of strokes that can be obtained by a skillful manipulation of the range of pencils given under the list of materials.

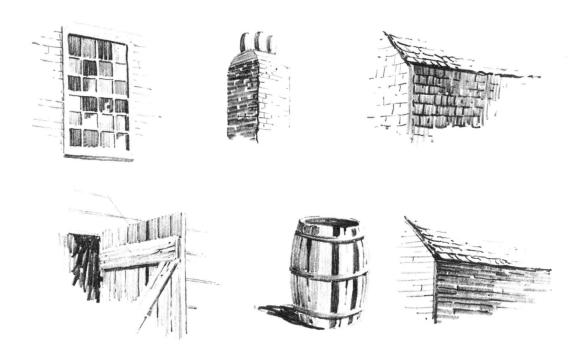

When studying the various examples of strokes and details presented herewith it must be borne in mind that each specimen has been reduced to about one half the size of the original drawing; in other words, each stroke was originally made twice the size that it appears in the reproduction. This is true of all the small sketches, with the exception of the strokes shown on page 10; these are actual size.

The reduction of the plates that follow, as has been referred to previously, is to approximately two thirds the size of the original, which means that each stroke was originally half as wide again as it appears. A realization of this reduction is very important; otherwise the student is very liable to find himself deliberately trying to make strokes which are too thin, when instead he should be striving for more broadness of line.

Attention is called to the fact that, for the most part, the direction and character of the strokes is suggested by the material—in representing clapboards, for instance, the logical stroke is a long horizontal one, quite different from that used to represent bricks, which again, varies considerably from, let us say, grass strokes. Curved surfaces necessitate curved lines—flat surfaces either vertical or horizontal lines, according to their nature.

The use of the pencil requires a wrist movement, instead of an arm movement, like that of charcoal, or oil painting; hence, the dimensions of the drawing board, as previously mentioned, in order to insure a support for the wrist.

Most students (and many artists) make the mistake of using but *one* pencil, depending upon pressure to give variety to their tones. This is a serious error. The stroke should at all times be firm and crisp—enough to lay down the slight "tooth" which even the smoothest of paper possesses. It is best to keep the full set of pencils (already mentioned) at hand, selecting carefully which pencil is needed for each different line, or tone.

Let us now assume that some time has elapsed, and a certain familiarity with the pencil, and efficiency of stroke, has been acquired. We are now ready to attempt our first composition, either from nature, or a photograph. Much of its success will depend upon the selection of the subject. It should be fairly simple, of course, but aside from its simplicity, it should be one that is adaptable to pencil treatment. It is almost impossible to say what constitutes a good pencil subject; one just acquires such knowledge through constant observation. It is taken for granted that one who contemplates beginning the practice of outdoor sketching, has an inherent love for nature, especially its picturesque spots and bits. Since this is so, it will gradually become apparent that certain subjects lend themselves to pencil treatment more readily than others. One will soon find that wherever he goes, certain scenes will literally cry out "PENCIL" to him.

Having selected your problem, study it very carefully for a few minutes to determine just what is most striking, unusual, or interesting about it, and then by looking first at it, then at your blank paper, then back at the scene again, try to visualize just how the finished sketch should appear and how the focus of interest should be emphasized. Care should be taken not to have more than one focus of interest. By placing your darkest darks, and your greatest contrast there, and by letting the drawing "vignette" or fade away on all sides, everything will be subordinated to this center. Do not attempt to "square up" the draw-

ing; that is, do not draw a line around it, and then bring all the strokes flush

with this line. Avoid any suggestion of straightness near any of the four edges, like a tree trunk, for example, and above all do not bring a branch of a tree or anything into the extreme corners. Doing this always makes the sketch appear too photographic.

Draw in very carefully with the hard pencil, not only the main lines, but the outlines of all the shadow shapes, and masses, as well, so that when the rendering is started, the mind can concentrate wholly on the values and technique, and not have to concern itself with the drawing, besides. The more preliminary drawing that is done, the better the final results are bound to be. A good way to phrase it is to make an outline map of everything that is to be drawn.

Make every stroke directly — never "scumble," or go back over a stroke the second time. To get the "wash" effects, or flat tones, apply the strokes closely together. In this way, the individual strokes are more or less lost. When the desired result is detail, simply keep the strokes more separated. Only by strict observance of this rule will the work appear crisp and sparkling.

Always be sure to have an extra sheet of paper under the one on which you are working; otherwise, when any pressure of the pencil is brought to bear upon the drawing, the grain of the board is bound to press through and affect the appearance of the strokes.

Some artists prefer to begin their rendering in the upper left hand corner, gradually working towards the lower right, so as not to have to move their hand over the strokes so much, while others commence with the focus of interest, by

indicating at the start the value and position of the darkest dark. No general rule as to procedure can be given; either way mentioned has certain advantages, and

with practice, one way or the other will become more natural. In any case, a piece of scrap paper should at all times be kept under the hand in order to avoid smudging, and also to frequently test out the pencil strokes.

Under no circumstances should the pencil strokes be rubbed, or "stumped," as in charcoal, as this always destroys the fresh appearance, and makes a greasy looking tone.

Do not forget that we must have *contrast*, at any cost. Too much emphasis cannot be laid upon this factor, for a pencil drawing without contrast, no matter how well it may be done in other respects, is an absolute failure. The ways by which such contrast may be obtained are legion, and as each drawing presents characteristic problems of its own, it would be useless to attempt to give any set rules for bringing about this condition. Some typical ways of producing contrast follow, however.

Always avoid a monotony of stroke. As has already been stated, the character of the stroke may largely be determined by the nature of the object being represented. A too short or choppy stroke is not as a rule desirable, yet at times, if used with proper discretion, it may

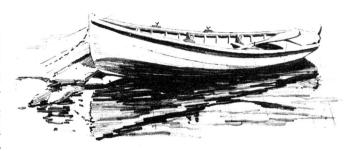

serve as a relief from too many sweeping lines. Examples of this may be seen in the rendering of shrubbery, brickwork, grass, etc. Remember Variety in strokes is just as essential to the spice of a pencil drawing as it is in life.

Bringing dark masses against light, and light masses against dark, at the focus of interest, also affords an excellent means of contrast.

Extremely important, too, is the leaving of white paper. The parts of a drawing that are left white, or in other words, not rendered, are just as necessary as are the parts that are drawn. Only by leaving certain areas white can sunlight or sparkle be added to the scene.

The roof of a house, for instance, does not have to be made dark, simply because it appears that way, providing that for some special reason it should be left light any more than it should be light if it would obviously appear better dark. Suppose that in reality the roof is quite dark, but that behind it is a mass of dark foliage. How much more it will snap out if kept light, or even white. It is always easier to go back and tone down a space which seems too light, than it is to lighten up an area that is too dark; therefore, leave plenty of white paper until the final touches are being applied.

When a sketch is finished, if a piece of smooth wrapping paper is pasted over it, in the form of a flap, it is not necessary to "fix it." The use of "fixatif" is very liable to ruin the delicate grey tones of the pencil. If the drawing is first mounted, and the flap pasted to the mount, it will stand a reasonable amount of handling without becoming rubbed.

A good way to do, if one intends to work much in the open, is to take the drawing board, already described, and nail on the back three narrow strips of wood

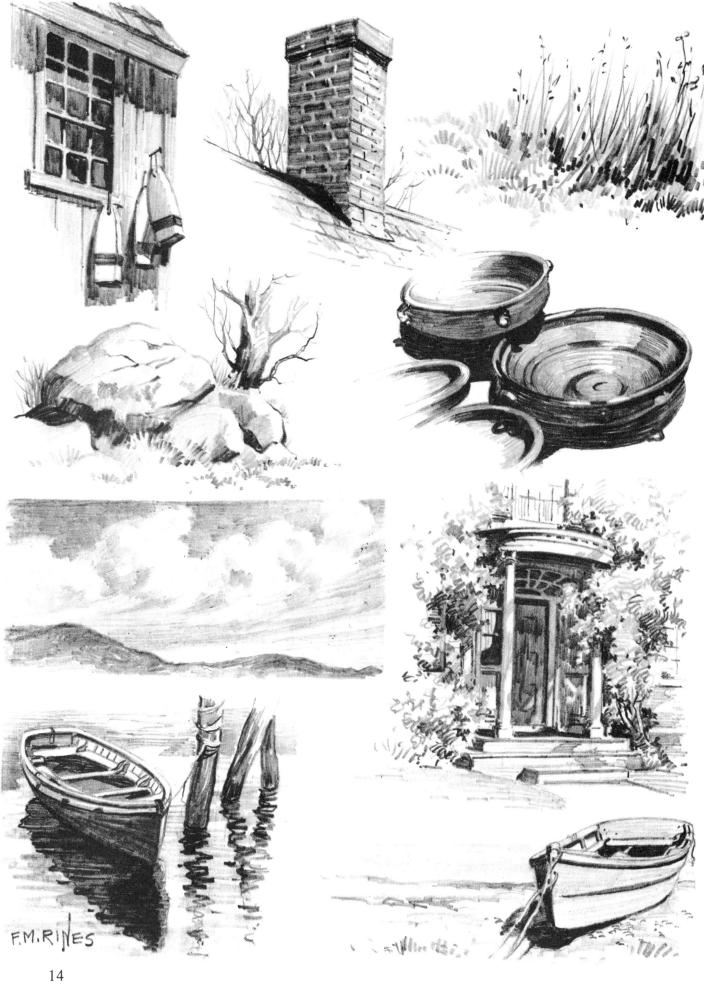

about 1/2 inch square to the bottom, and the two sides. To these strips tack a piece of oilcloth, allowing enough extra at the top to form a flap. This makes a very convenient pocket in which to carry extra sheets of paper, as well as the finished sketch, and does away with the necessity for a portfolio. It has the added advantage, since it is waterproof, of protecting the paper when caught out in a sudden shower. The oilcloth can be very easily renewed, when it becomes worn.

In conclusion, the student must constantly be reminded that nothing but continual practice will bring to him the success which he desires. Do not be afraid to put down something on the paper; even if it doesn't look just right, the realization of the fact that it is wrong means that something has been learned.

By doing this, you will gradually become less and less conscious of your pencil as a tool, leaving your thoughts more free to concentrate on the other elements of the picture.

Remember to keep the leads well flattened by use of the scratcher or nail file and to always bear down as firmly as possible. Even then the pressure will vary somewhat, but this slight inequality of tone will not, as a rule, be objectionable.

Do not get discouraged; remember that others have had to travel the same road, along which there are no "short cuts" to the art of pencil sketching.

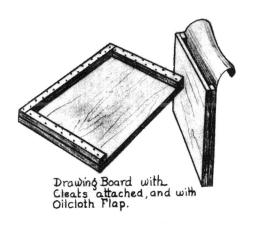

FOCAL POINT

Always avoid having any dominant lines or edges come in the exact horizontal or vertical middle. In A the farther corner of the building and the horizon line do this. Observe, in B, how the position of the building and the horizon line have been shifted.

Never have any object which is capable of movement (such as boats, figures, animals, etc.) facing directly out of, or away from the focus of interest. If this is done, the eyes are pulled away from this focal point.

Note how the boats, which in A both point outward, have been rearranged in B so that they direct the attention toward the middle.

Also avoid crowding too much interest into the corners where it will be entirely disconnected from the rest of the composition. The small boat which in A seems to be an afterthought and pulls the gaze away from the building (the subject of the picture) is placed in B so that it not only points inward, but becomes part of a unified composition by means of the reflection tones.

In C, besides further illustrating the importance of avoiding the middles, the road-way starts in one corner of the picture, drawing the attention toward the right and out of the composition without focusing the attention at all on the trees which are the subject. In D the eyes follow the roadway and are led right up to the trees. Also, the very uninteresting triangle, in the lower right corner of C, becomes in D, a more pleasing shape.

In E, the two tree trunks have been placed so that they hide dominant lines of the houses. Such placement causes the composition to appear too formal and obvious. Note how much more informal F becomes because these trunks have been drawn in slightly different positions. Such placing is equally important when drawing masts of boats and when adding accessories such as figures, etc.

As a similar example, notice the tip of the mast and its relation to the ridegpole in A. Now observe the change made in B by simply extending the tip a trifle.

It is well to bear in mind that, as a rule, uneven numbers—one, three, five, etc.—make for better composition than even numbers. Hence, three boats in B instead of the two in A, the three trees in F in place of the two in E, and the one large tree in C and D. While not a hard and fast rule like most of the others spoken of here, compositions generally are improved when this proportion is followed.

In E and F the street, running diagonally across the picture, might seem to violate the principle of C and D. The fact that it is so broken up with shadows, however, offsets any such effect as occurs in C.

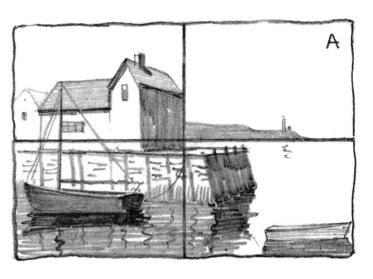

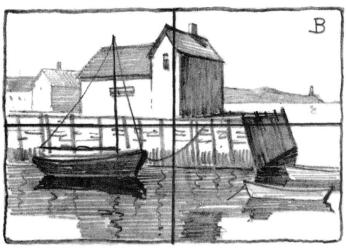

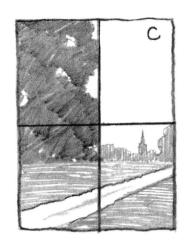

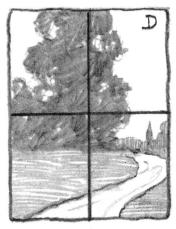

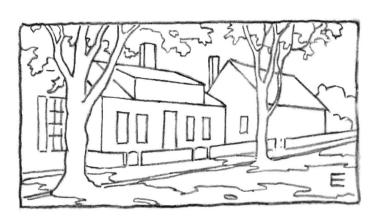

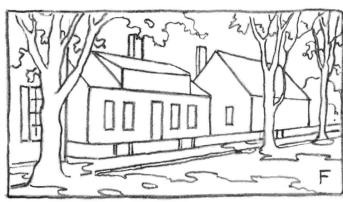

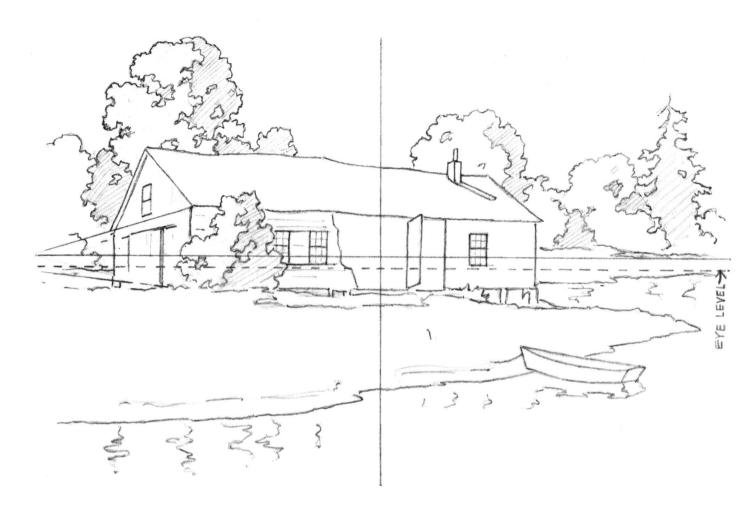

PENCIL TEXTURE

This outline, like the other outline drawings in this book, had to be made heavier in order to reproduce. The point to be emphasized is the importance of having everything carefully planned before any rendering is done.

Cover up the boat with your finger and note how the composition loses much of its interest. Try to visualize it placed somewhere to the left of the middle line, and notice how heavy the composition would then appear on that side.

The change of texture on the shadow side of the building helps to break up what would otherwise be a monotonous expanse.

Naturally, in the process of rendering, a few variations from the original outline are introduced in order to enhance the effect, e.g., the few bare twigs in the bush in front of the building, a few suggestions of grass, etc.

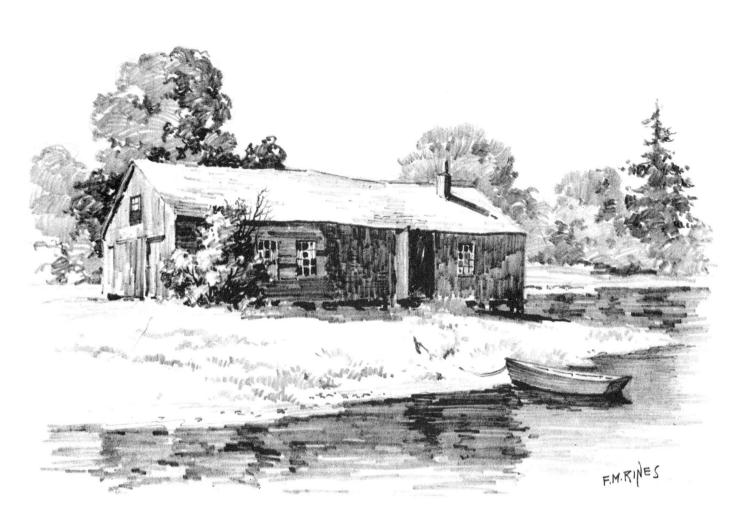

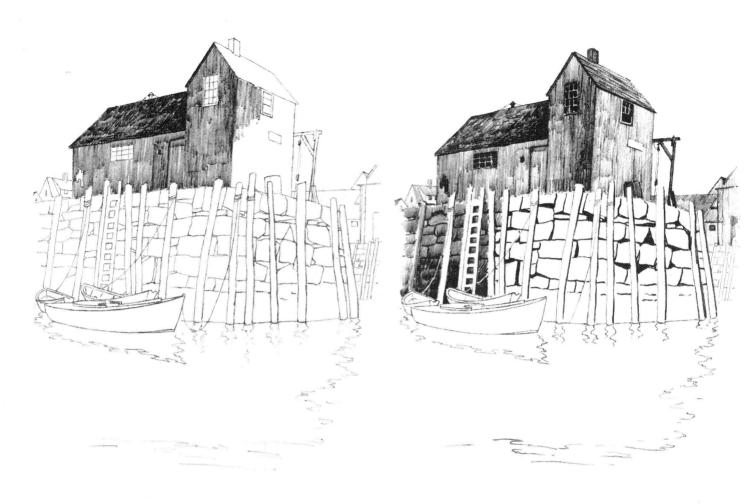

STEPS IN PENCIL RENDERING

THESE incomplete drawings serve as an illustration of the progressive steps in producing the finished drawing opposite.

After making the careful outline, render the vertical walls of the building with an HB for the side and an F for the front. Make the dark roof next, using a 2B and then the lighter roof with an F, turned slightly edgewise, to make a more lined effect. Then add the accents of the boards and shingles with the sharp edge of the HB, and then the windows, etc., with the 2B. Use an H pencil for the buildings in the background.

Outline heavily with a 2B or 3B (according to the amount of pressure) the shapes of the stones and fill in solidly the crevices between the stones. Next tone the stones with the HB for the light values and a 3B or 4B for the seaweed at the waterline, leaving the piles until the stonework is done. Then tone the piles.

Render the water next, with a B and a 3 or 4B, using a very free stroke.

Leave the boats until the water is finished. Notice that while the individual strokes in the water are not mechanically straight, the general effect is horizontal.

On the boats, let the strokes follow the contour of the boards.

The clouds and seagulls are added last of all.

This drawing is an example of one of the few compositions that are effective in pencil on a cloudy day. The bulky silhouette against the sky takes the place, in a measure, of the contrast of light and shade in the other drawings in this book.

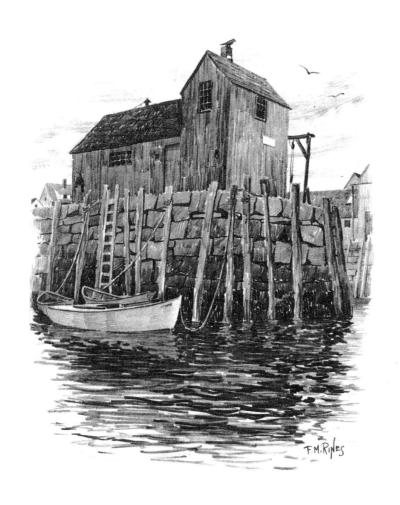

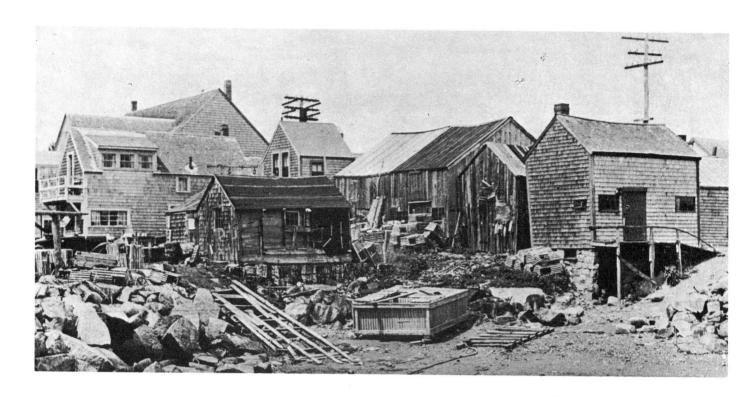

SKETCHING

This photograph was taken in order to show the conglomeration of material that often exists when we are looking for sketchable subjects. The drawing shows one of several compositions that can be made from such material. It emphasizes the point that an artist "copies" from his subject only what he desires, eliminating and transposing the rest, and introducing other objects as he feels the need for them.

The shack with the tarred paper roof has been moved toward the right, eliminating some of the expanse of the building with the long, broken roof line. This building has been drawn, as it is in the photograph, slightly out of perspective. In reality the building is tilted because the sills have partially rotted away. This effect has been retained in the drawing in order to make the shack look old and weatherbeaten.

This scene was purposely taken with almost no sunlight and shadow effects. In the drawing the lighting has been changed, thereby obtaining a much more interesting result. The introduction of the steps, lobster traps, etc., supply notes of secondary interest, which the photograph lacks.

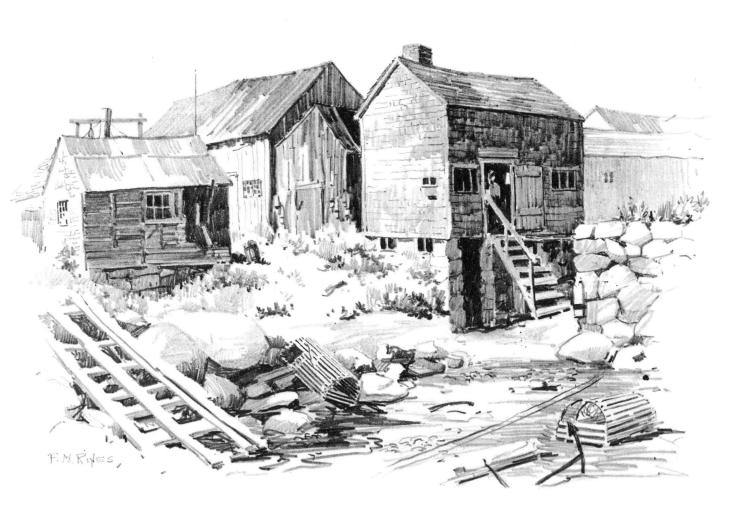

The points brought out here would apply equally well, if the drawing had been made from the actual subject instead of from the photograph.

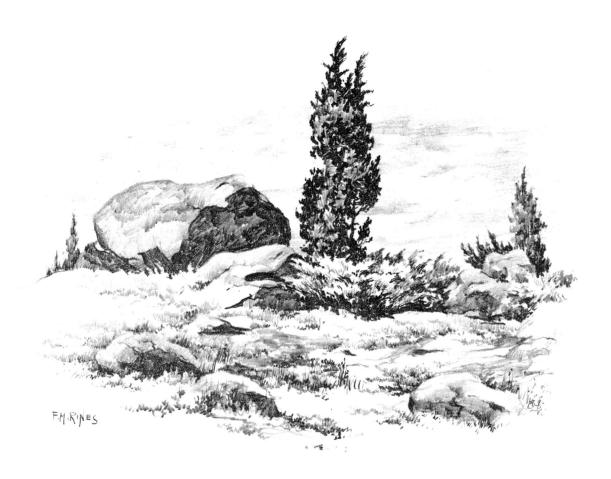

COMPLETING THE SKETCH

This illustrates how, after the subject has been carefully drawn in outline, as shown on page seventeen, the entire background of the clapboards on the shadow end of the building is worked around the silhouette of the shrubbery. The softening touches are then added to the shrubbery, as in the completed drawing below. In this manner you can decide just how much or how little modelling the foliage requires.

The upper part of the gable end in shadow has been left unfinished in order to illustrate the guide lines which indicate the perspective or direction of the clapboard strokes.

This upper sketch is reproduced the actual size of the original drawing.

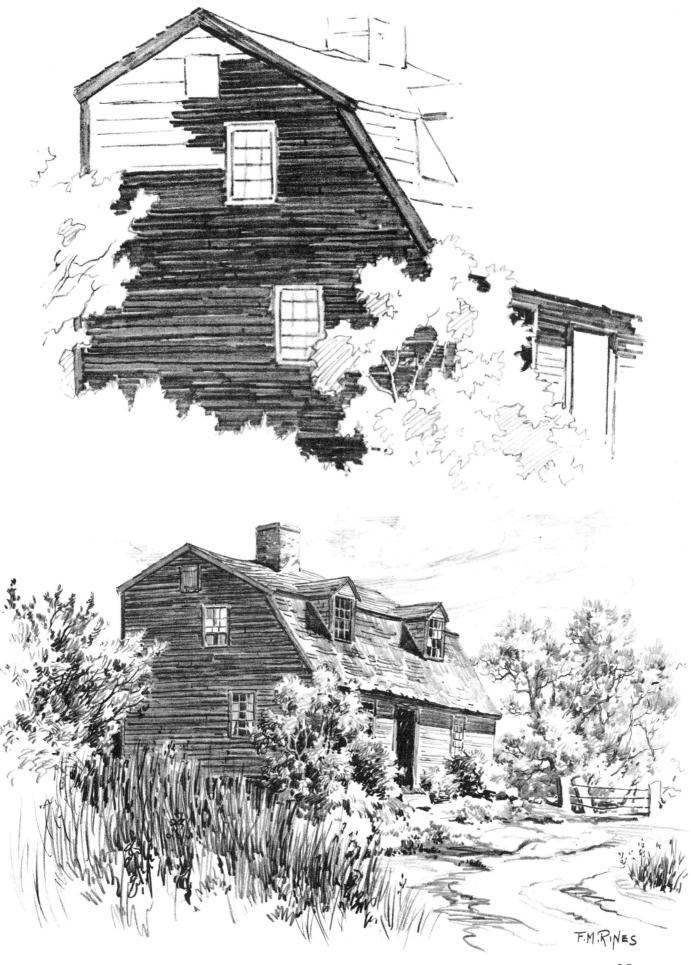

PERSPECTIVE

WHEN complete books have been written about perspective, it can be readily understood that the subject can only be broached here. These few examples will, however, give an idea of some of the governing principles. Nearly everyone realizes that the farther away an object is, the smaller it appears. Observation helps the artist to determine the angle of vanishing lines and the proportionate size of diminishing objects, but a working knowledge of the theories of perspective forms a valuable aid to such observation.

In many magazines and newspapers innumerable photographs of houses, street scenes, and buildings may be found. If you will, with a straight edge and a soft pencil, follow to their conclusion the various lines and edges in these pictures, your understanding of these principles will be greatly increased.

The horizon, or eye level, is exactly what the name implies—i.e.—the level of the eye when viewing the object. This eye level, therefore, will be raised or lowered as one's position becomes higher or lower. Every horizontal line, if projected far enough, will eventually cross this eye level line. Every horizontal line, IN THE SAME PLANE, or THE SAME SURFACE, will, when projected, meet this eye level line at the SAME POINT, called the VANISHING POINT.

Obviously, then, when the eye level line is somewhere between the upper and lower edges of a plane or surface, some of these lines will have to slope upward and some downward. Reference to the accompanying diagrams will make this clearer. Not only will all the lines in this plane vanish to this one point, but all the lines in every PARALLEL plane will vanish to this SAME POINT.

In the case of almost every building or similar object, the two sides or surfaces that we see from any one station point are at right angles to each other.

Therefore, whatever is true of all the horizontal lines of one plane is true, in the reverse, of all the similar lines in the plane which is at right angles to it. This means that the lines in this second plane will vanish to a point at the OPPOSITE end of the eye level line. The rapidity, or acuteness of the angle at which they vanish is determined by the angle at which this plane is with the station point of the observer.

There can be but ONE EYE LEVEL LINE in any picture, and only ONE VANISHING POINT for all PARALLEL PLANES. There will be, however, as many vanishing points, all on the same eye level line, as there are planes at different angles to one another.

While only one of the vanishing points is shown in these diagrams, the approximate locations of the other vanishing points are indicated.

There is one exception to the above statements. If the observer is stationed exactly in front of an object, so that only one of its four vertical planes can be seen, the perspective then becomes so subtle that it can be ignored. Such views are used a great deal in architectural renderings, and are known as "elevation views." As they are not, as a rule, "artistic," and therefore not a wise selection for a freehand treatment, further reference to them can be dismissed here.

With the foregoing statements in mind, diagram A should be obvious. B is an illustration of the problem encountered in A, complicated by the addition of a fence and sidewalk. Since this building is situated on sloping ground, that is, since the ground is not horizontal, and the fence is built in relation to the land rather than to the building, the rule for vanishing horizontal lines can not be applied to it. The width of these will, of course, diminish as they recede, but not in accordance with the eye level line.

Diagram C should need no further explanation.

Diagram D illustrates two new principles. They still relate to the fact that everything appears to diminish as it recedes. The lines a b and c d divide the gable ends into two parts, the width of the nearer parts being greater, BECAUSE THEY ARE NEARER TO THE EYE. For the same reason the dormer window is slightly more distant from the nearer corner of the building than from the farther corner.

We know, of course, that in reality the eaves and ridgepole are the same length. Yet the ridgepole is more distant than the eave. Therefore, the lines x must eventually converge, as must the two lines y, in order to make the ridgepole lengths slightly shorter than the eaves. These two principles are more often neglected than any of the other principles of perspective.

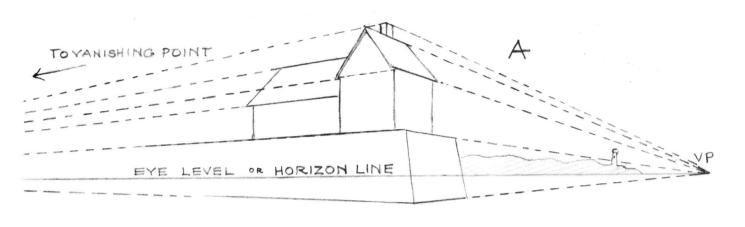

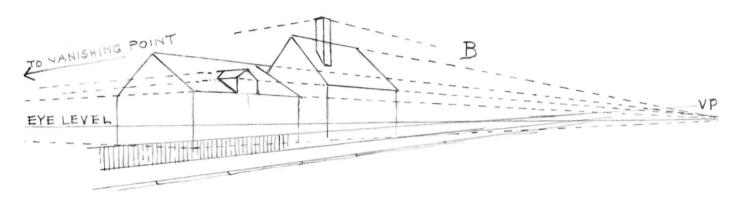

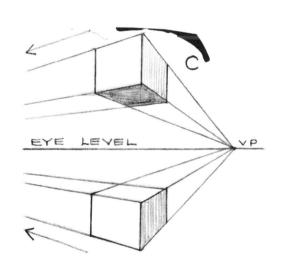

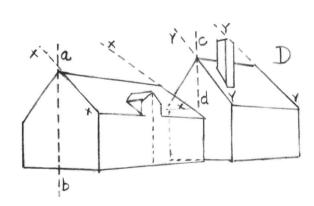

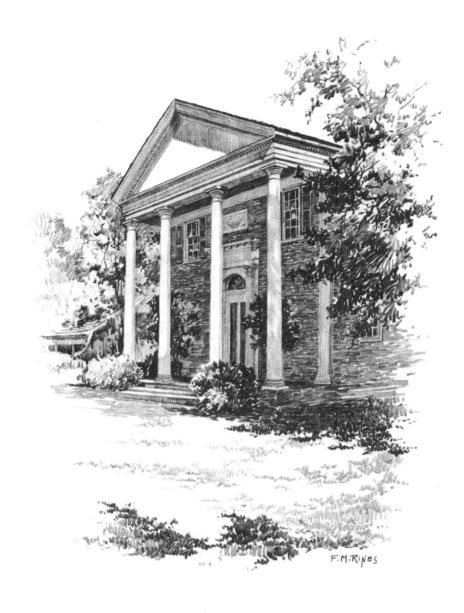

INTERESTING TEXTURES

This drawing, and those on the two following pages, serve to further demonstrate some of the principles mentioned in the preceding pages. The one on this page is especially interesting because of its perspective. The one on the next page shows some interesting textures. The last one illustrates how to treat different foliage masses in their relation to one another.

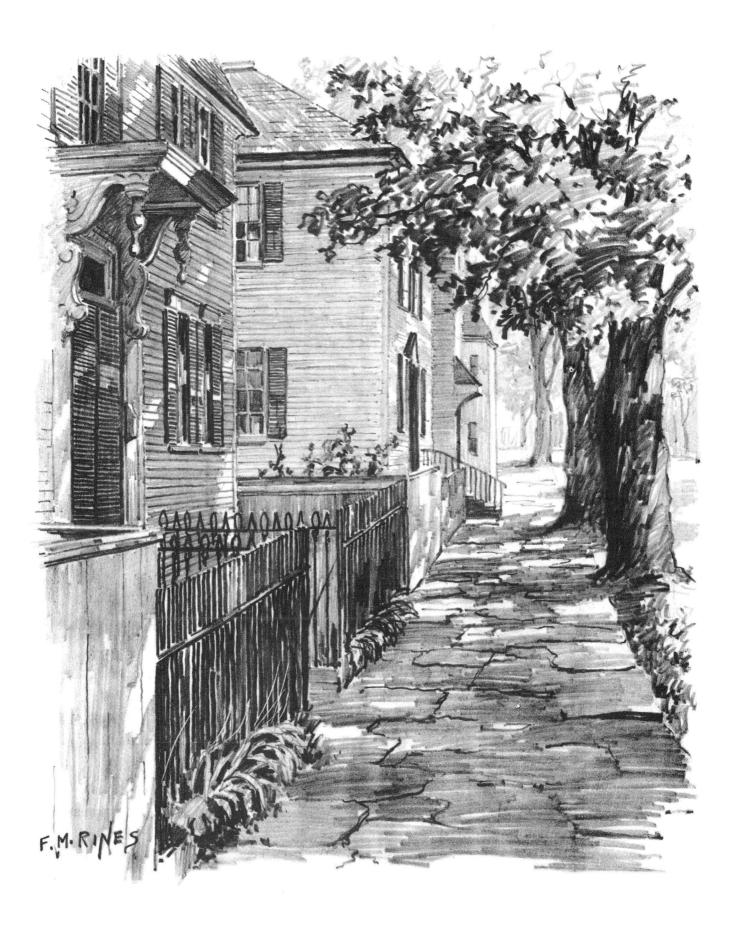

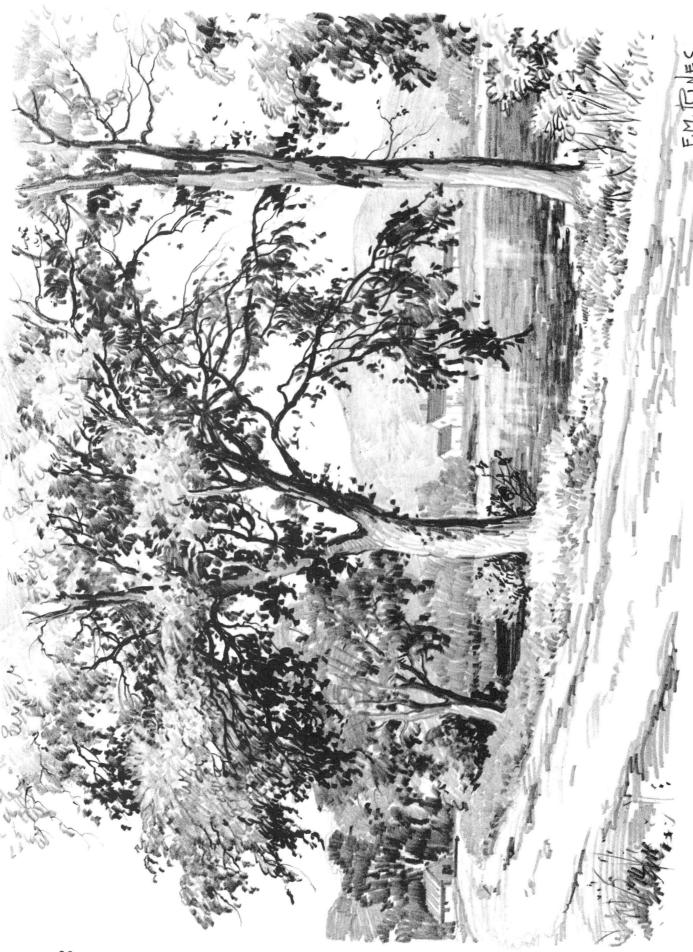

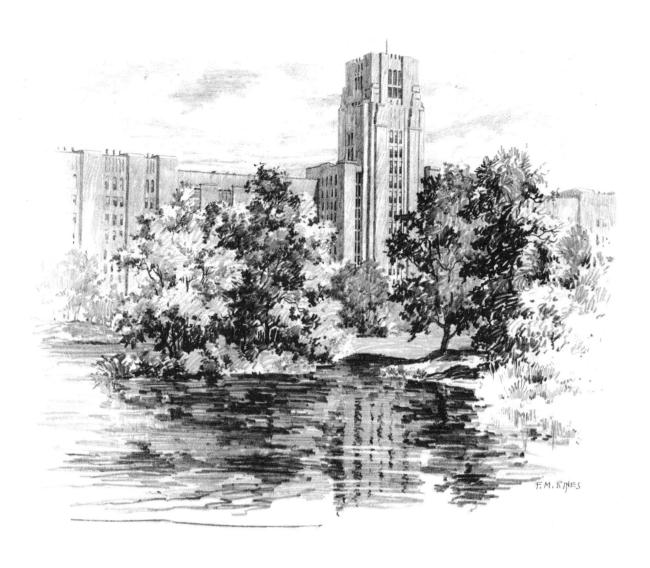

CONTRAST OF LIGHT AND SHADE

Notice the delicate light foliage. It is sometimes sharply silhouetted and sometimes lost against the grey tones of the building. (It was drawn very carefully in outline, first.) Against the sky, the other tree (upper left) is darker. The different planes of the rocks have been suggested by strokes which vary in their direction.

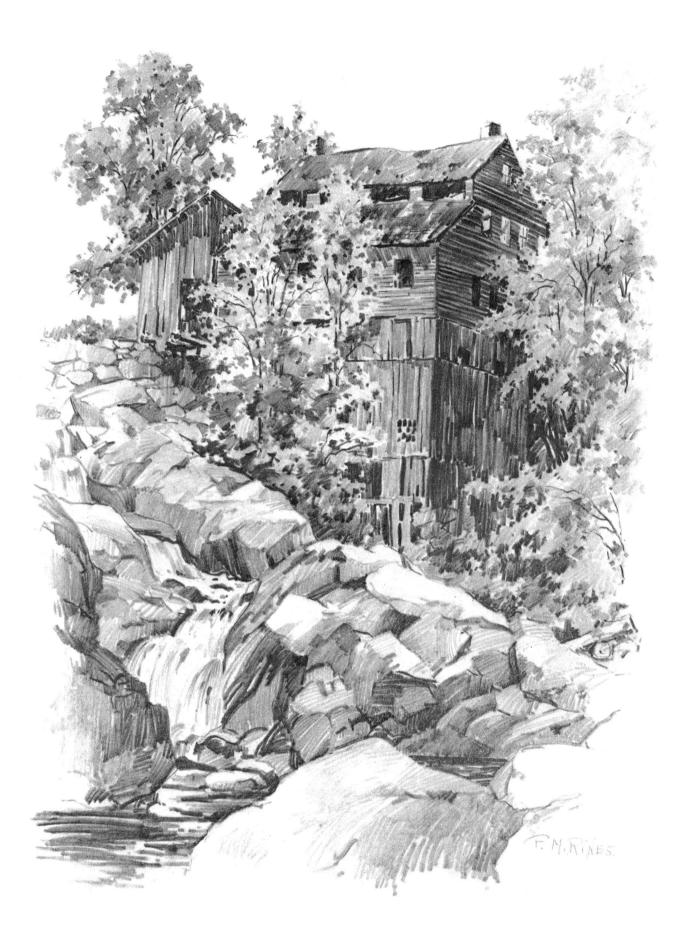

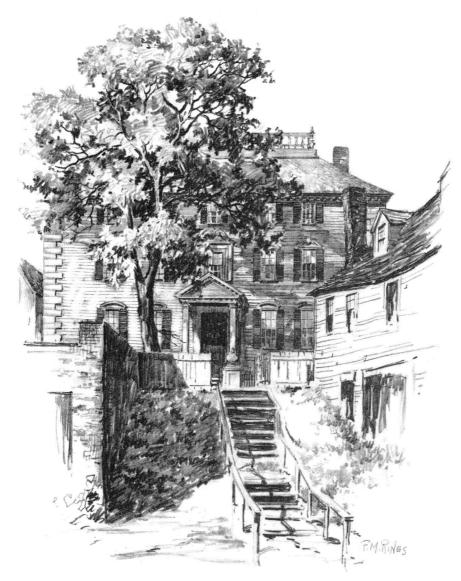

When I was in Art School a fellow student remarked to me, "I don't see what you find so interesting in drawing trees—they're all alike." No statement could be farther from the truth, or show less understanding of and appreciation for nature than this.

TREE CONSTRUCTION

Undoubtedly, one of the most difficult things to draw, or paint, is trees and foliage. Many artists spoil an otherwise good piece of work by perpetrating what never did, or could exist in nature, and calling it a tree. This whole treatise could well be devoted exclusively to the subject of rendering foliage and shrubbery, but lack of space forbids. That the matter receive more than passing mention though, is essential.

One reason why so many trees are poorly drawn, is because so few artists have realized the need for studying their formation and growth, both

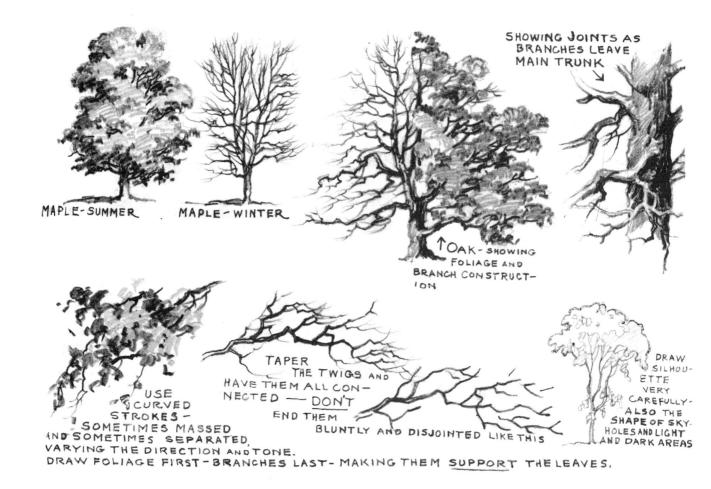

as groups, and as individuals. For anyone who is going to draw or paint out of doors, a thorough acquaintance with the Anatomy of trees is just as essential as

the knowledge of human anatomy when working from the figure. Each species of tree has certain marked characteristics, and each individual tree of each species also has marked characteristics, just as each individual of the human race has distinctive marks. The more one studies these marks of identification, and learns to be constantly on the watch for them, whether actually about to sketch or not, the more pleasure he will derive from nature.

A very good plan is to make infinite drawings and studies of bare trees in the early spring, late fall and winter.

In the rendering of trees in particular, one should bear in mind the chance for variety offered by the *direction* of the pencil strokes. Different masses, light and shade, the way in which the twigs grow from the branches and the leaves from the twigs, may all be suggested by the way in which the pencil is handled.

Make a small hole about $\frac{1}{2}$ inch in diameter, in the middle of a piece of paper. Holding this near one eye, with the other closed, look at the middle of a mass of foliage (either in a photograph or in nature) (see sketch). Nothing but a green spot will appear; except for its color it might be anything, or nothing at all. Now move the paper so that part of the edge of the tree and sky show through the hole.

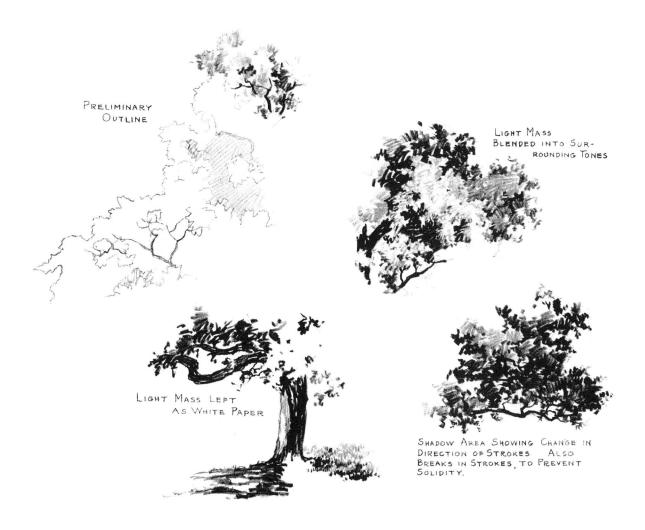

Immediately the fact that you are looking at a tree becomes apparent. Now try the same test with any of the foliage in the sketches reproduced here.

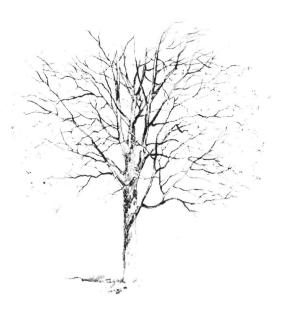

This proves that it is the *silhouette* that determines the character of a tree. Notice the difference between the silhouette or growth of different kinds of foliage; that of the elm and the maple, for instance (see plates). See how logical it is to bring out this difference by means of the pencil strokes.

Also remember that a tree is something through which the wind can blow, causing the leaves to tremble and rustle; therefore, keep the edges soft and lacelike, and while not actually drawing each separate leaf, indicate the difference between foliage, shrubbery, etc., and building and masonry; in other

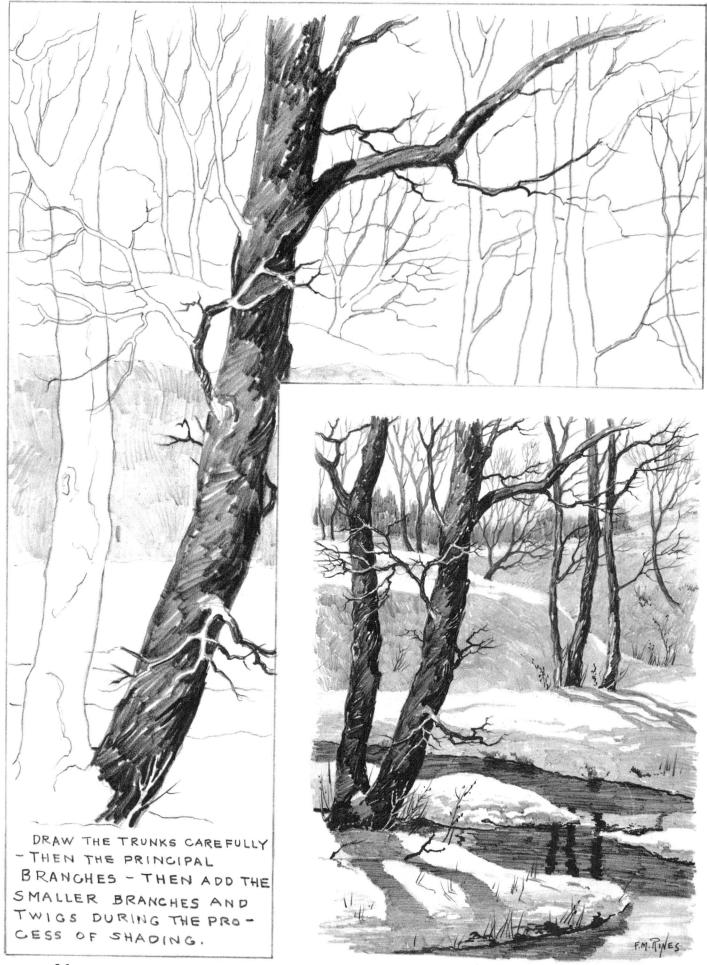

words, the difference between the growth of nature and objects made by man.

It is also advisable oftentimes, even though the tree from which you are working has exceptionally luxuriant foliage to let the sky show through, and to draw in a few branches and twigs. These should be made with considerable care, however, and conform as logically to the growth of the trunk as though the naked tree were being shown. Keep them of about the same value as the leaves; if they are too dark or heavy, they will stand out too prominently.

Great attention should be paid to the design, not only of the tree itself, but also of the separate masses. Frequently in nature, trees will be found to

be ugly in shape. For example; one side will form too much of a straight line, or the foliage mass will appear unbalanced in relation to the trunk.

As an artist, whose purpose is to create a thing of beauty, why not change such ugly features?

Another mistake that is frequently made, is to have the shape of a clump of foliage resemble some definite form, such as a dog's head, or other animal. Usually just a stroke or two will remedy this defect.

A few words as to fore grounds, another difficult part of the picture. Generally a few vigorous strokes of

the softer pencils, applied in such a manner as to suggest the contour of the ground or water, will suffice. When rendering water, take great care that the strokes are either absolutely horizontal or vertical; otherwise the water will have the appearance of being uphill. Oftentimes the importance, as well as the proportion of some comparatively insignificant growth or object in the foreground has to be exaggerated in order to give distance to the scene. It is usually the difference between the flat washes and lack of detail in the background and the openness, boldness, and suggested detail in the foreground that gives what we call "aerial perspective" in a drawing. Be sure that the foreground, as the name implies, comes forward.

Before closing, a word or two regarding erasing may not be amiss.

When it becomes necessary to change some part of the sketch, a small piece of the kneaded eraser should be broken off, and well kneaded between the fingers, until it becomes quite moist. Then use

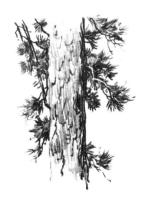

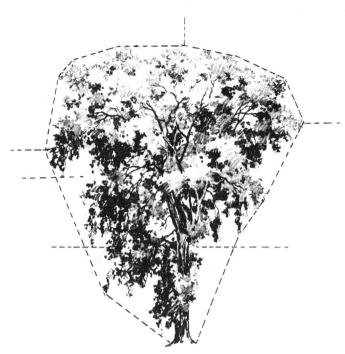

then when the dark tone is put over this line it will stand out white, as the pencil will slide over it without leaving an impression. This is purely a "trick," however, and as such, should be resorted to very seldom. Used promiscuously, one's work is apt to appear too mechanical.

this to lift off (not rub) as much of the line or tone as possible, before proceeding to use the other eraser, in the usual manner. The Art gum is handy chiefly to remove dirt and finger marks from the edges of the paper when the drawing is completed.

Once in a while, where it is necessary to have a fine white line against a dark tone, like a small branch of a tree or grass or reeds against a dark water tone, the sharp edge of some metallic substance (a coin, or key, for instance) may be used. Using great pressure, draw with this as if it were a pencil, making a sharp, indented line; will stand out white, as the pencil This is purely a "trick," however, Used promiscuously, one's work is

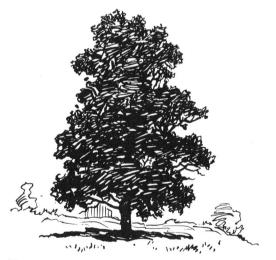

MAPLE. NO SUNLIGHT -APPEARS FLAT.

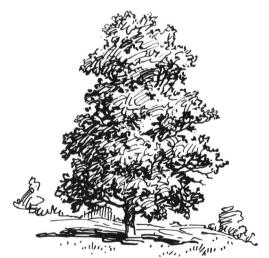

SAME MAPLE-WITH LIGHT AND DARK MASSES, APPEARS ROUNDED.

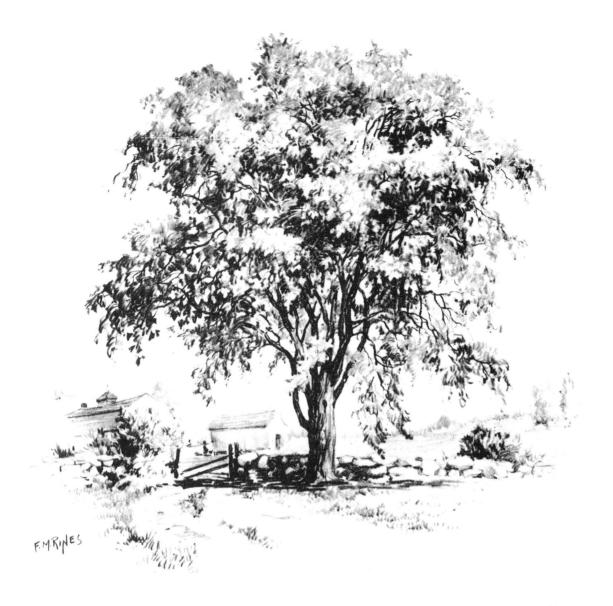

ELM. Medium — Pencil. The elm is one of our most widely distributed as well as most graceful trees. Although the leaves are medium sized, the many fine twigs produce definite masses, which catch the sunlight and consequently cast contrasting shadows. The weight of the foliage causes the finer branches to droop even more than when the tree is bare; therefore, the pendulous masses are very evident, especially in the lower part of the tree. The silhouette is often rather flat at the top, with sufficient open spaces to show sky and branches. Elms frequently appear like the smaller tree in the Winter sketch — tall and narrow, instead of spreading, but with the same characteristics of twigs and foliage massing.

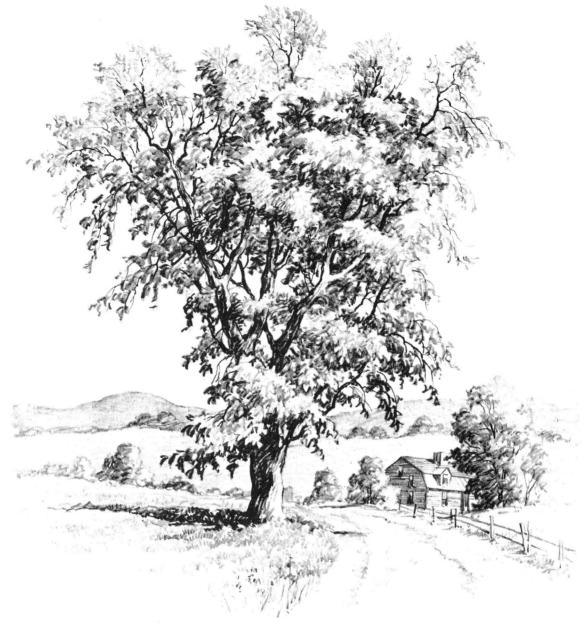

ELM. Medium — Pencil. A comparison of this elm tree with the one on the preceding page, and also with the other elms shown throughout the book, demonstrates what has already been said — that no two trees are ever alike, even though they possess many similar characteristics. One of the most outstanding features of the elm is the pendulous branches, especially the lower ones.

In drawing these, take care not to make them look like bunches of grapes hanging straight down as if there were no life in them. Note how they vary in direction and how, nearly always, there is a tendency toward an outward or upward direction.

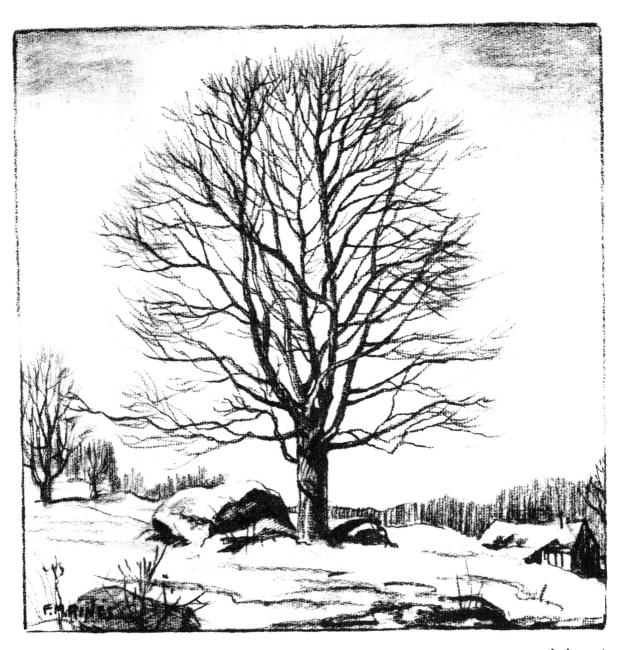

MAPLE. Medium—Charcoal on White Charcoal Paper. The sugar maples' main trunk frequently extends to the height of the tree, unbroken by divisions, instead of as shown here — otherwise the character of the branch growth is the same. Most of the upper branches extend outward and upward, gradually changing to a more nearly horizontal direction nearer the base. The smaller twigs and branches are quite sturdy, and, while not as gnarled and tortuous as the oak, are not drooping or pendulous like the elm. This drawing and that of the birch in Winter have been reduced more than the other drawings because the charcoal, being a less delicate tool than the other media, is easier to work on a somewhat larger scale.

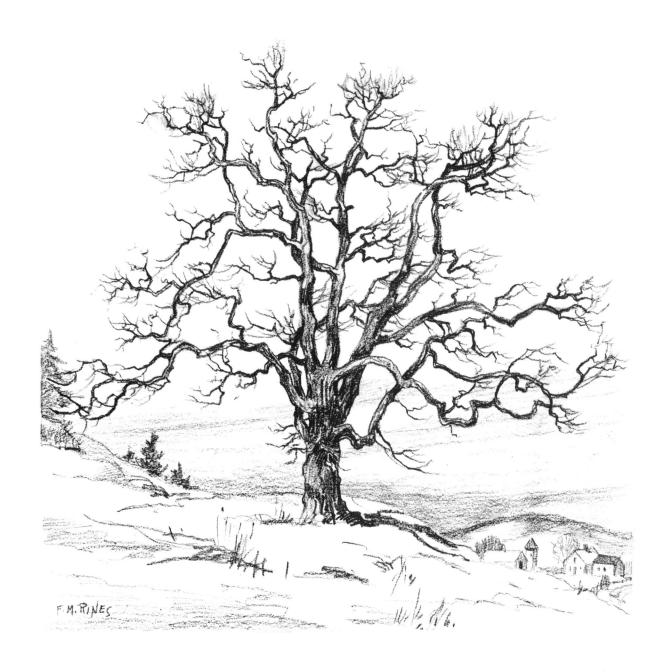

WHITE OAK. Medium — Carbon Crayon on Medium Surfaced Stock. The sturdiness or ruggedness of the oak is one of its outstanding characteristics. When growing in the open, as it very frequently does, it is a wide spreading tree, with the lower branches extending almost horizontally for a considerable distance, and often, as in the one illustrated (an old, considerably weather beaten specimen), angular and tortuous. The twigs, also, while inclined to be rather short, are very angular, and reach in all directions. The main trunk often extends the length of the tree, instead of dividing, as this one does. When sheltered by surrounding growth the dead, brown leaves often remain on the tree throughout the Winter.

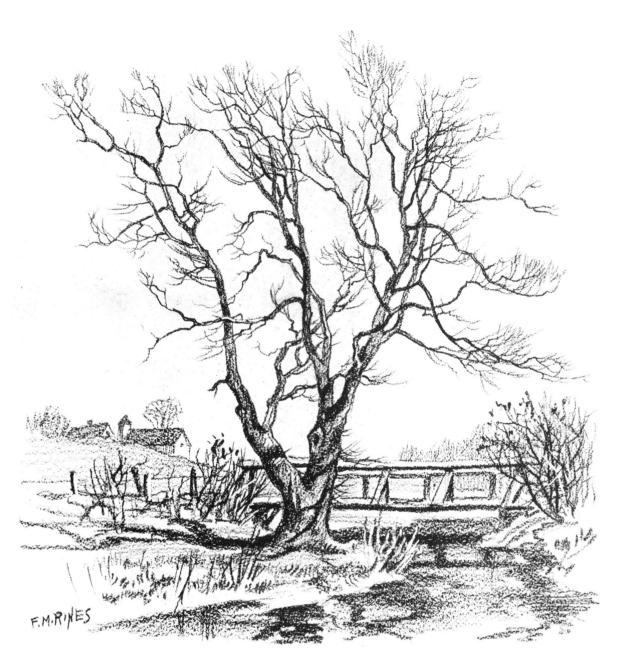

WILLOW. Medium—Carbon Crayon, on rough surface. The willows vary greatly in structure. Since the wood is brittle, storms often break large branches. These branches, unless entirely separated from the tree, continue to grow. As a result, the appearance of the willow changes a great deal from year to year. The tendency of the twigs is to grow upward from the larger branches. These larger branches grow in all directions; some grow almost horizontally from the main trunks, and are often gnarled and distorted. Willows usually grow in low land where there is more or less moisture, and along the banks of streams. While not a graceful tree, the willow is almost always picturesque, and, therefore, fits admirably into compositions.

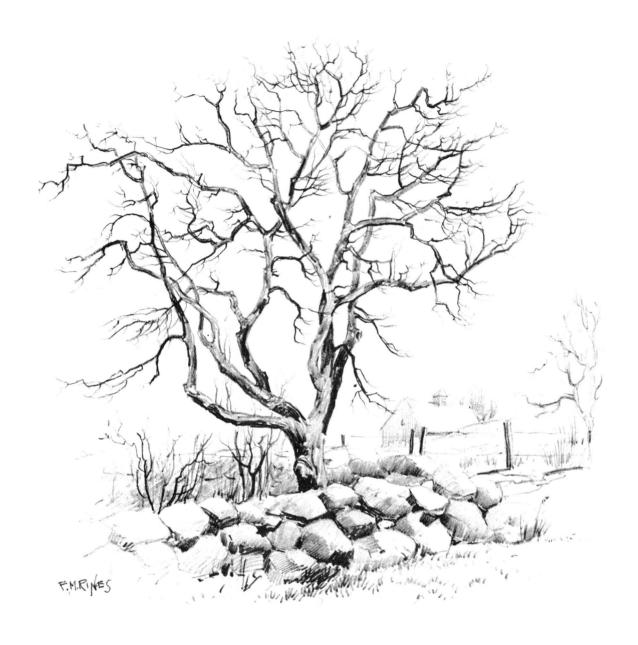

APPLE. Medium—Pencil. No tree varies more in general form and no tree, when allowed to grow naturally, is more interesting or picturesque, than the apple tree. Some of its outstanding features are its twisted, oftentimes writhing limbs and its angular twigs. Contrasting with these, on old trees are frequent straight shoots, or "suckers" as they are called. On well-trimmed trees these latter are cut off, as they sap the life of the tree. Due to the weight of the fruit in Summer, most apple trees show traces of where some limbs have been broken off. In the Spring, there is no more beautiful sight than an apple tree in full blossom. It is next to impossible, however, to attempt to produce this effect in black and white. Color alone can do it justice.

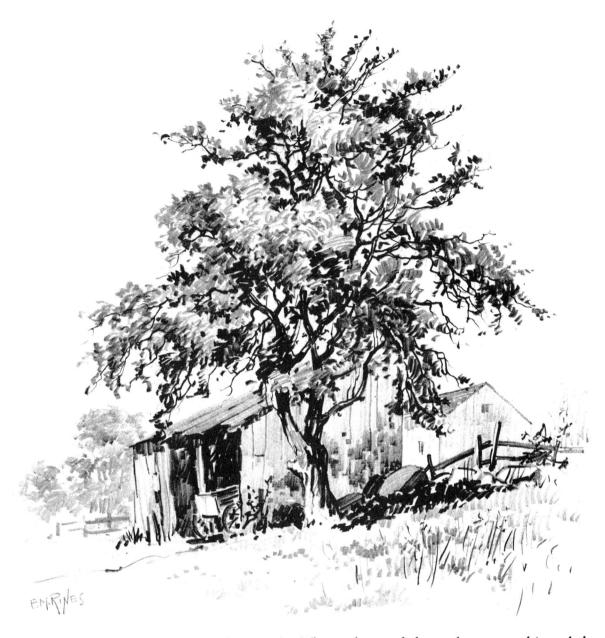

APPLE. Medium—Pencil. The entirely different forms of the apple tree on this and the preceding page are only two of thousands that these interesting trees assume. One feature of apple tree foliage that makes it distinct from that of other species is the straight, new shoots sticking out at all angles from the general massing. While these are especially evident at the top of the tree, they occur more or less around the edge. While usually not as thickly foliaged as some other trees, the leaves grow quite massed on some branches, consequently giving an opportunity to show much of the construction, or anatomy, in some spots, as well as sunlit masses in other places. Compare the absence of symmetrical silhouette of these trees with the opposite extreme of the maple.

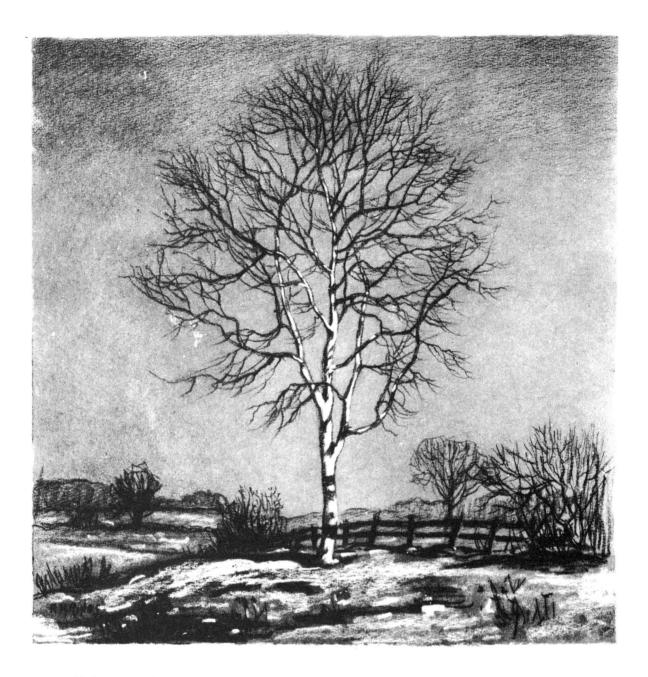

BIRCH. Medium—Charcoal and White Chalk on Toned Charcoal Paper. While not a large tree as a rule (it seldom exceeds thirty or forty feet in height) the birch is always a conspicuous note in any landscape. This is due largely to its snow white bark on the main trunk, in sharp contrast to almost any background. The smaller limbs and twigs are quite slender and graceful, and are dark brown, sometimes almost black in color, forming a dark triangular shaped spot where they branch out from the trunk. The dark patches where the white trunk has been girdled, so frequently seen, affords a further pleasing contrast. The birch is an extremely hardy tree, often being found farther north than any other deciduous tree.

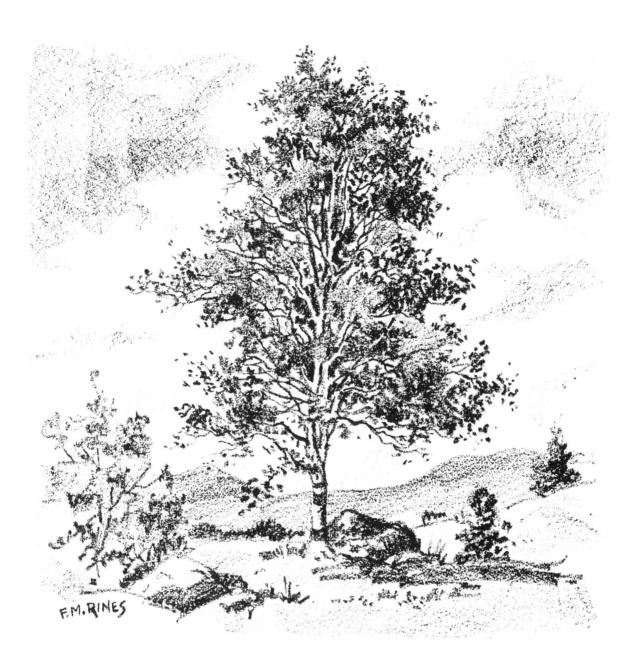

BIRCH Medium—Lithograph Crayon on Water Color Paper. The leaves of the birch tree are rather small and in many instances do not grow as thickly as some of the other trees. For these reasons it does not offer the opportunity for such distinct light and dark masses as does, for instance, the maple, the willow or the elm. The general appearance is therefore inclined to be flatter than these other trees. The contrast of the white bark on the trunk and the dark green of the foliage lends itself very nicely to semi-decorative effects in paintings. For the most part, when growing wild, birches appear in groups of from two to eight or ten, and when near a pond or stream lean out over the water.

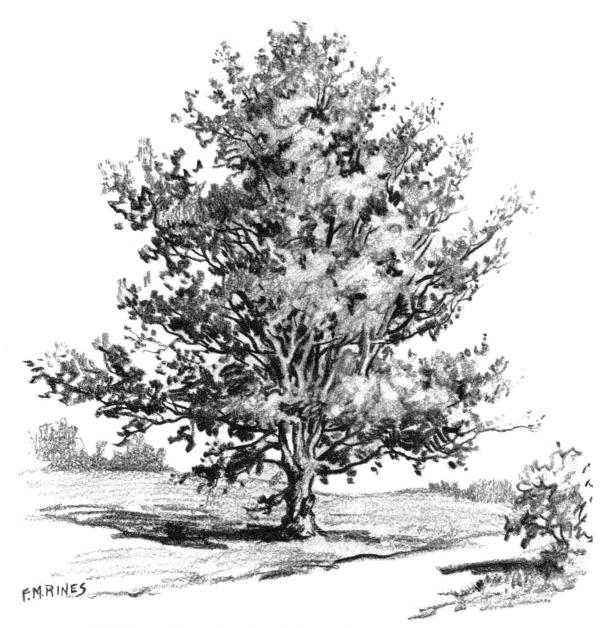

BEECH. Medium—Charcoal on Rough Surfaced Paper. The top part of this beech is much more pointed than the one shown in Winter. Both of these forms are equally typical. The foliage of beeches is a delicate green in the Spring time and yellow in Autumn, and combined with the bark color, already described, makes it an extremely interesting tree for painters, especially when growing along with other trees, more usual in coloring.

This rendering was smeared a little in the light areas and the highlights were then picked out with the kneaded eraser. Some of the light branches were produced in the same manner.

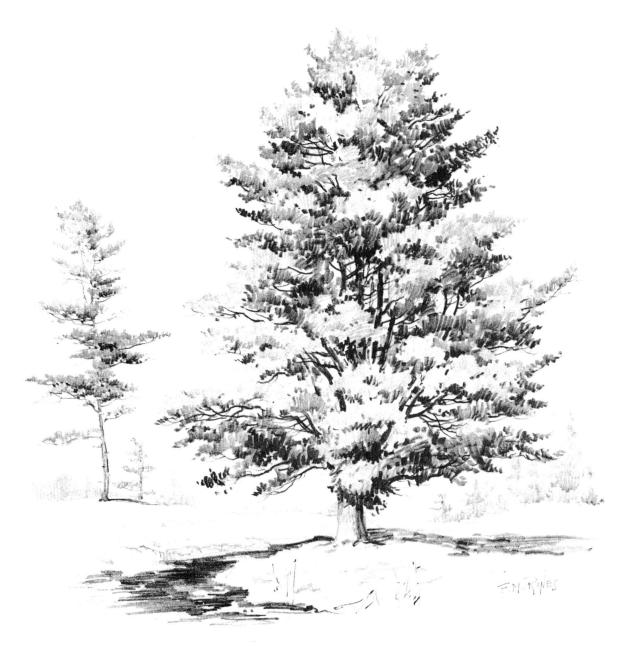

PINE. Medium—Pencil. This pine tree is termed a "pasture pine" — that is, it has grown entirely in the open, away from other trees. Consequently, the single stem so evident in other drawings, has in this case divided into several heavy limbs with an accompanying upward growth of branches. Eventually the same horizontal branches appear, however. The same vertical direction for both the pencil and the brush strokes is used, because they are so strongly noticeable in the actual foliage. The chief difference in the growth of the pine tree in comparison with most other conifers, is that on the pine the twigs grow upward from the branches, instead of downwards as they do on the others; also the branches themselves, on the spruce, hemlock, etc., have a tendency to droop.

SUNLIGHT AND SHADOW

Medium—Pencil. These two big trees are horse chestnuts, which have unusually large leaves. One of the most difficult problems in drawing trees is to show them against some background other than sky. Painting them in oils or pastels is much easier because the oils or the pastels, being opaque, can be superimposed over the background. In pencil, however, the design of the foliage must be exceptionally carefully drawn. Then the background must be rendered, leaving the foliage as white paper until this background is complete. The edge of the foliage silhouette must then be rendered, working from the background into the tree masses, breaking them up as much or as little as is necessary to bring out sufficient contrast.

By keeping the front of the house mostly in shadow and taking advantage of the aforementioned large leaves, which grow in clumps, is one way of solving this difficulty. Another way would be to reverse the arrangement of light and dark, i.e.—have the front of the house in brilliant sunlight and the leaves in dark silhouette against light.

The gnarled trunk of the tree on the left is very characteristic of the horse chestnut and affords a nice contrast with the texture of the house. Notice the difference in the branching of the two trunks. Both ways are typical.

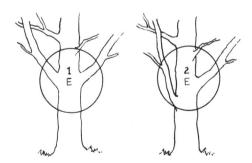

Raise or lower one of these limbs a little, at the same time change the thickness and angle a bit, and note how much more pleasing is the result (2E).

ROCKS AND WILLOWS

Medium—Pencil. This sketch depicts a group of willows growing so closely together that they constitute a miniature jungle. Each individual tree so lost its identity that the effect is not of a silhouette, but rather, a jumble of light and dark masses of foliage, interspersed with twigs, branches and trunks. To select a few of these foliage masses and to rearrange and compose them pleasingly is the problem confronting the artist, when faced with similar scenes. While at first glance, perhaps, the foliage, as represented here may seem to have little in common with that of the "portrait" of the willow, a closer inspection will reveal the same characteristic, fine leafy texture, the same gnarled and distorted branches and the same open and heavily massed areas.

The suggestion of sky, with the silhouetted trunks against it, which appeared in the actual view, was used to advantage in the sketch "not just because it was that way" but because it forms a welcome note of contrast to so much heavy massing of foliage above it. Observe the introduction of a bit of detail here and there, also for the sake of relief, from the broader suggested portions.

The large, simply treated rocks, further contrast the comparatively "busy" foliage areas, and the old boat and lobster trap add a touch of human interest to the scene.

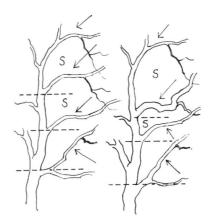

A reference to the accompanying diagram will illustrate more fully some of the foregoing points. The dotted lines indicate where three limbs of equal thickness, and growing evenly spaced on the larger branch, have been changed, both in size and spacing and direction, in order to give variety to the pattern. At the same time this re-arrangement prevents the two sky spaces (S) from being so nearly similar in shape and area.

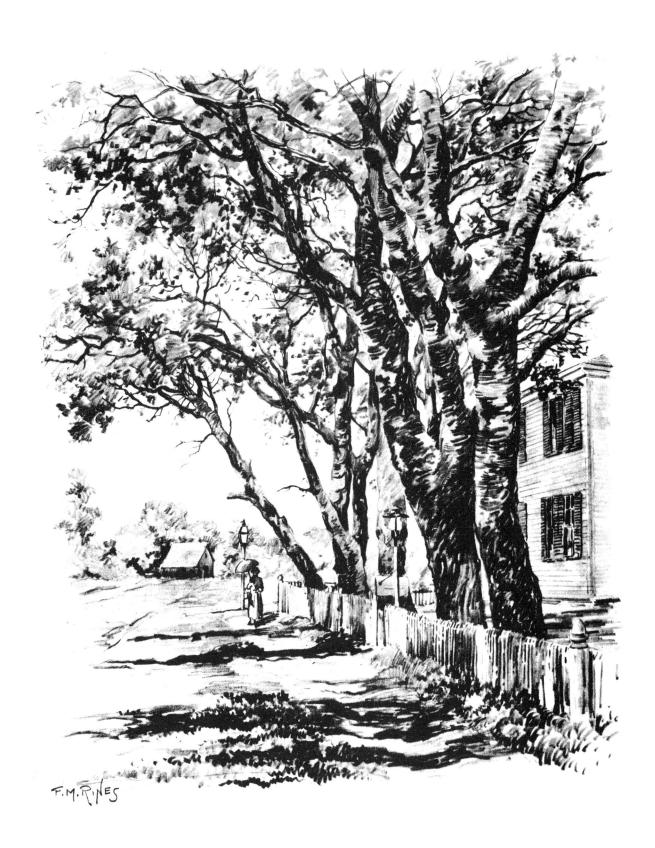

SILVER POPLARS

Medium—Pencil. "A Study of Tree Trunks" might be an equally appropriate title for this scene, for the interesting, gnarled trunks are the focus of attraction, and the foliage merely serves as a background for them. These trees (which unfortunately space does not admit including in the series of portraits) possess trunks, the bark of which is a peculiar yellow greenish grey in color, mottled with darker grey, or black. This spotting, together with the play of light and shadow cast by the foliage, lends an added interest to what would still be pleasing purely from the viewpoint of growth.

Observe how the direction of the strokes in some places suggests the rounded contour of the trunks, while in other places, in order to avoid monotomy, this rounded effect has been ignored.

Consider, in this drawing, as in the others, how important, if unobtrusive, a part the twigs play, in relation to the pattern of the foliage and the sky apertures.

The distant trees have been drawn somewhat stronger in value, with a little more attention to mass forms, than is the case in some of the other sketches. This is because the trunks in the foreground are so very dark and detailed, that this distance can stand more importance. It is entirely a matter of relative values.

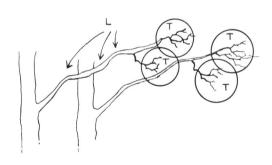

Try to get as great a variety in these twigs as possible, both in length and thickness. Just as the larger branches taper, so do the twigs. Instead of having them end with a heavy line, let them become thinner and thinner until they finally end with a hair line. (See T.)

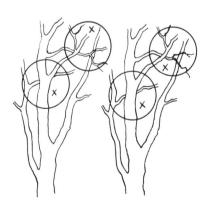

Draw them crossing one another, avoid as much as possible having two or more that are too obviously parallel, and do not have a twig or branch grow at exactly the point at which two others already cross. (Diagram X.)

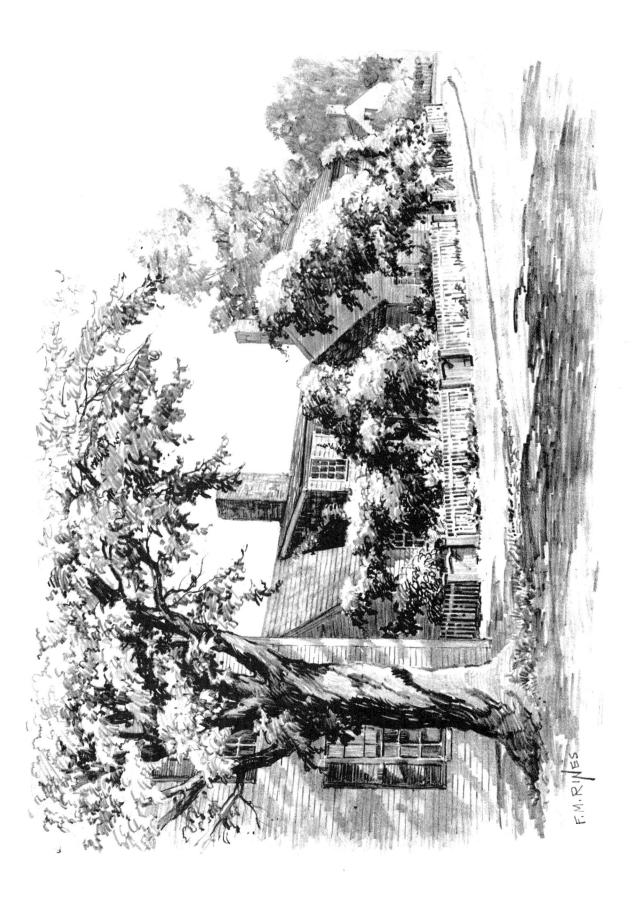

VINE COVERED COTTAGE

Medium—Pencil. This drawing illustrates, among other things, that vines and shrubbery, which are so closely akin to trees, must be drawn (or painted) with the same principles in mind. In one sense, perhaps, they are even more difficult than trees, since very often, as is the case here, there are no twigs or branches to help out the effect. That means that the light and dark masses must be played up to their fullest extent in order to make the drawing interesting. The vine shown in this sketch is heavily massed wisteria.

A suggestion of hollyhocks and other garden flowers behind the fence—not too important in relation to the composition as a whole—is made by simply silhouetting them in white against the dark shadow of the wisteria. Only in a painting could these be emphasized more.

Note the difference in the treatment of the large elm in the foreground and the very much less important maple on the right. The actual elm towered up extremely high before branching out at all. If it had been drawn that way it would have directed the attention out of the picture and would not have been nearly as interesting since it would have appeared as all trunk. This is just one instance where an artist has a great advantage over the photographer.

Take especial care when one large branch appears partially behind another for some distance to redesign one of them a little. This will prevent the illusion of the two limbs appearing as one abnormally thick one and then suddenly diminishing to a much smaller size (D).

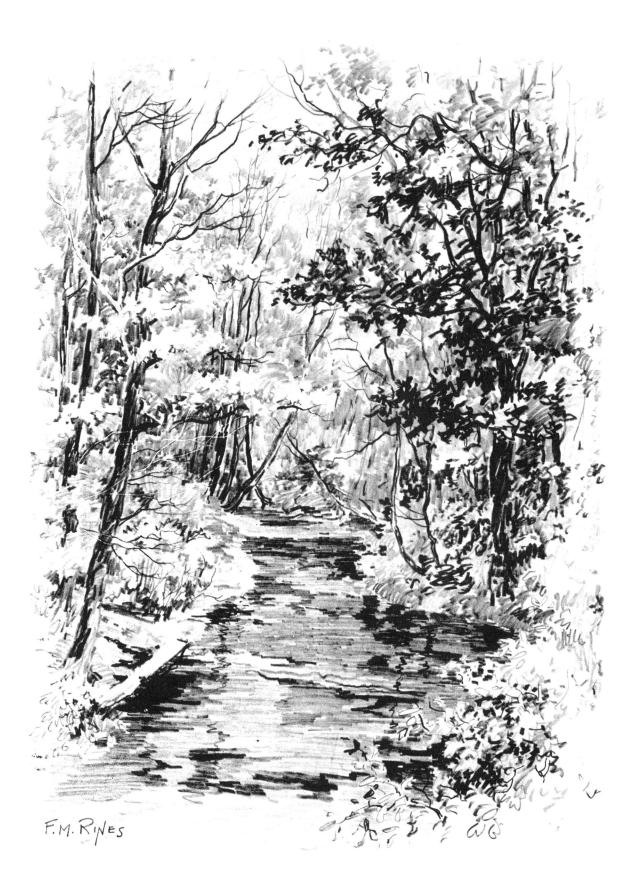

TROUT BROOK

Medium—Pencil. Here is a different problem, and an extremely difficult one. Very little individual tree character is distinguishable. The growth happens to be composed of young oaks and maples, interspersed with alders and other shrubs. This fact is of minor importance, however. The important thing to bring out in the drawing is the juxtaposition of light masses against darks, and, vice-versa, the subordination of the background — a series of indefinite, closely valued tones—and the exaggeration of scale in the immediate foreground. All of which is another way of saying that receding planes of the picture must be emphasized as much as possible.

It can readily be seen that no one could possibly draw this scene as it actually appeared. All that can be done is to take certain existing material, discarding nine-tenths of it, and to rearrange or recompose the remainder into an impression of what was there. At the same time, sufficient knowledge of the material must be at hand, so that the observer of the sketch will absorb the idea of an actual flowing stream, the banks of which are choked with trees and undergrowth, instead of thinking that the artist was practising pencil strokes, or trying out a new set of colors.

Remember the foliage is something through which the wind can blow, causing the leaves to tremble and rustle; therefore, indicate in the outline the soft and lace-like edges. Handle this outline in such a manner as to suggest the abovementioned quality and to create the impression that it is different material from the buildings, rocks, boats, etc., that may also be in the composition. (See diagram.)

Another thing to bear in mind is that all trees have three dimensions—that they have depth as well as height and breadth. So many times they are drawn and painted as if they were flat, like a piece of paper. Usually in photographs, also, they have the appearance of being all one tone, with little or no modeling in them. In the case of the photograph this effect is due to either one or both of two things; the film is not sensitive to the different color values, or else the picture was taken with the sun behind the tree.

But we, as artists, should be able to improve upon the camera.

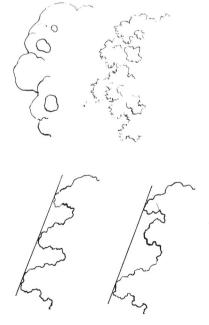

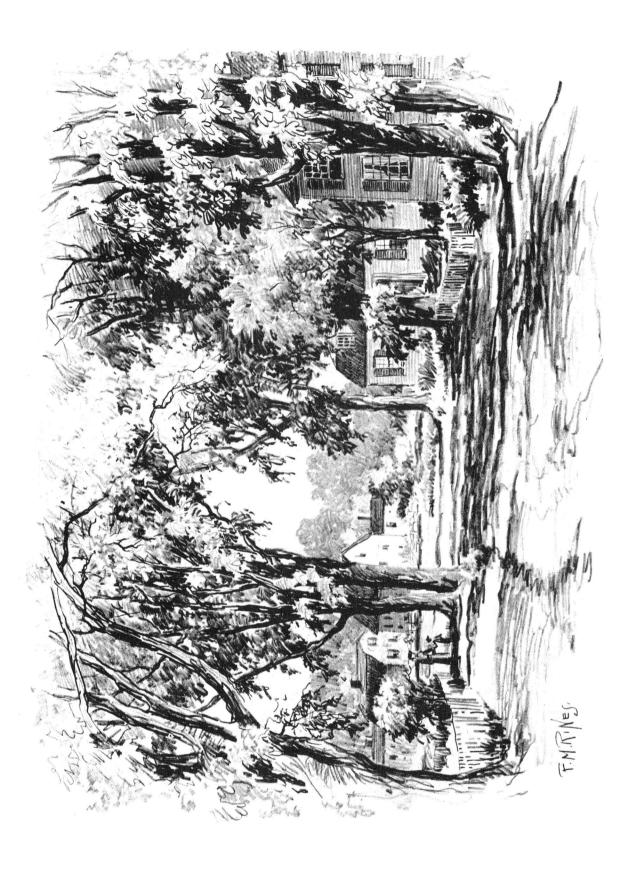

THE EDGE OF THE VILLAGE

Medium—Pencil. The successful rendering of a scene of this nature depends largely upon the treatment of two distinct factors. One is the bringing out of certain details and the subordination of the rest, and the other is the relative spacing of the tree trunks. Of course, these elements enter into every problem of composition to a greater or less extent, but in this particular type their importance is increased.

This double row of old elms could easily appear monotonous if their trunks were spaced at too regular intervals. Their position here is only one of a variety of location which they might occupy. It would be interesting to experiment, by means of some very rough sketches, with various placings of these trunks, in order to prove to yourself just how important this matter of space relation can be.

The very light value of the bunch of foliage on the tree at the extreme left, contrasted with the foliage in deep shadow immediately behind it, and the light, suggested detail of the leaves at the right bring these two masses into the foreground.

The small tree, between the two houses on the right, while of no particular character by itself, makes an interesting note of contrast in its relation to the other masses.

In every tree, as we must have discovered in our study of the bare trees, the tendency is for the topmost twigs to grow in a more or less vertical direction. In some species, as well as in some individual trees, this direction is more evident than in others, but it always exists to some degree. Once we get away from the top, however,

the change of direction of growth differs considerably. Compare, for example, the elm and the maple and the oak. (See diagrams.)

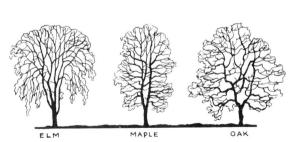

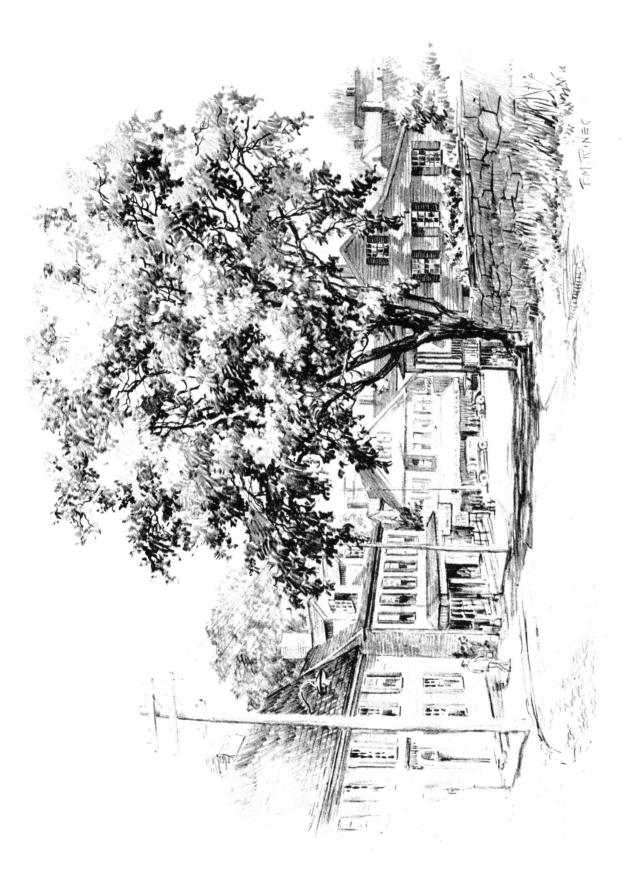

MAIN STREET — U. S.

Medium—Pencil. Although the title of this drawing definitely puts it into the classification of "street scenes," the elm tree is fully as, if not more, important that the buildings. In fact, the reason for selecting this particular view and angle was because of the tree with its interesting contour standing out so clearly against the sky. Cover up the tree with a piece of paper and see how uninteresting the scene becomes. Now try to imagine any old tree in its place with no particular attention given to either its silhouette or its interior pattern. Try to imagine it rendered all in one tone without the same feeling for sunlight that the houses show. The average photograph would picture it that way, because, as mentioned elsewhere, the film, unless a filter was used, would not be sufficiently sensitive to the subtle color gradations.

And yet the gradations are there for all to see. It is up to us, as artists, to take advantage of them and to make them interesting.

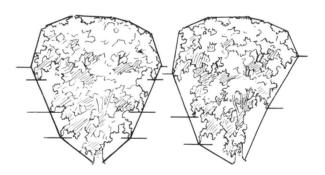

Does the whole silhouette have the appearance of informal balance? Are the different masses varied enough as to size, shape, and continuity? Are they distributed in such a manner that the tree does not have the effect of being divided right through the middle in respect to the light and shade areas? Are the skyholes sufficiently varied in character so as not to seem made with a rubber stamp?

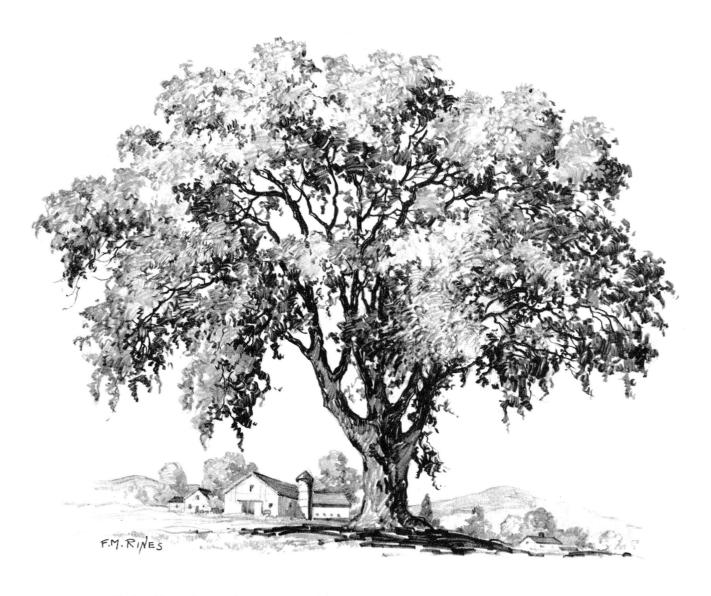

To be able to draw and paint trees and have them look like trees and not just strokes, or gobs of paint, is the supreme test of a landscape artist's ability. A visit to some of our art galleries will convince any one that some of the exhibitors still have much to learn in this respect.

THE COVERED BRIDGE

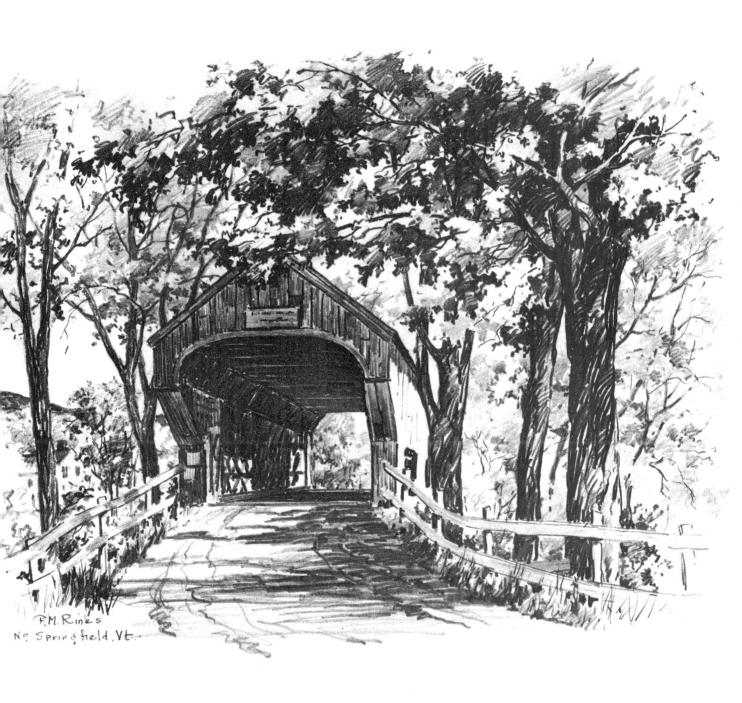

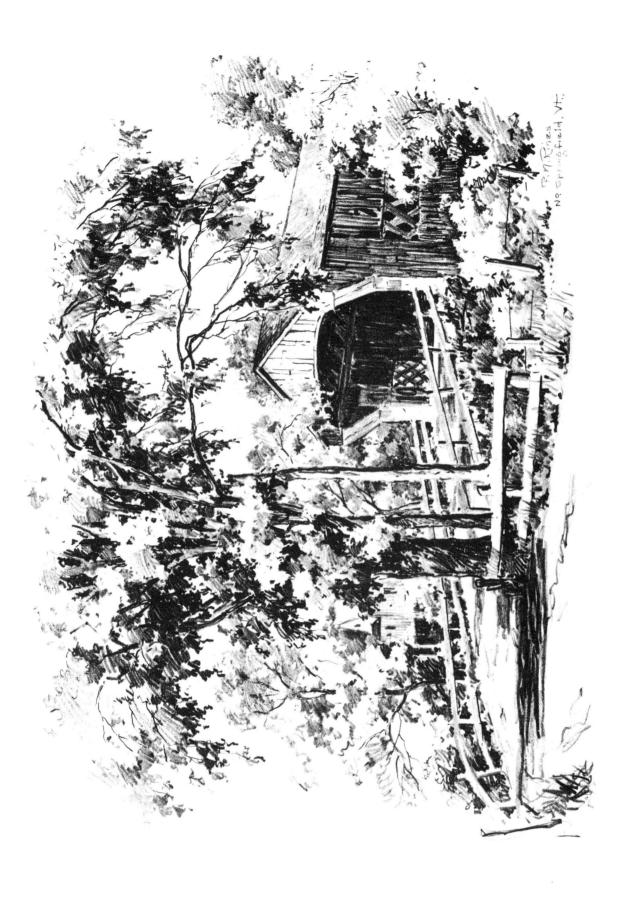

COVERED BRIDGE, VERMONT

As in the other covered bridge pictured here, the approach to it is one of its interesting features. Like so many other objects, a covered bridge, if taken by itself has little to recommend it, from the artistic viewpoint. Placed, however, amid a setting of natural scenery, half obscured by foliage, and the leading lines of the roadway and its accompanying white board fence, it becomes a subject at once picturesque and romantic.

The manner in which the direction of the strokes conform to the growth of the leaves is especially evident in the large tree. On the left hand side the general direction of the strokes is downward from right to left, while on the other side they are downward in the opposite direction. For a person who is naturally right handed, the right hand side of a tree is always more difficult to draw than the other. The easiest way to make this stroke is with a sort of backhanded motion. A little practice and it becomes quite easy.

The branch of foliage in front of the bridge, serves the same purpose as in so many of the other sketches.

THE COUNTRY LANE

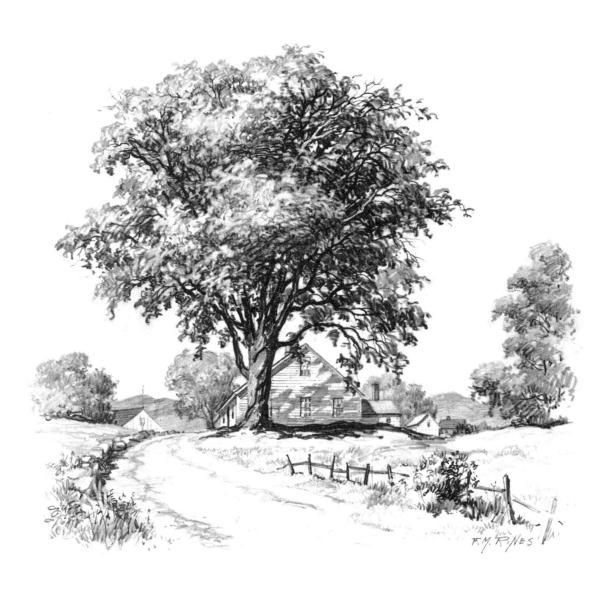

Do not, above all things, be satisfied to complete the outline with three or four curving strokes that make it appear like something cut out from a plank or piece of wall board with a jig-saw. This may sound far-fetched, and yet I have seen it done many times.

THE OLD SWIMMING HOLE

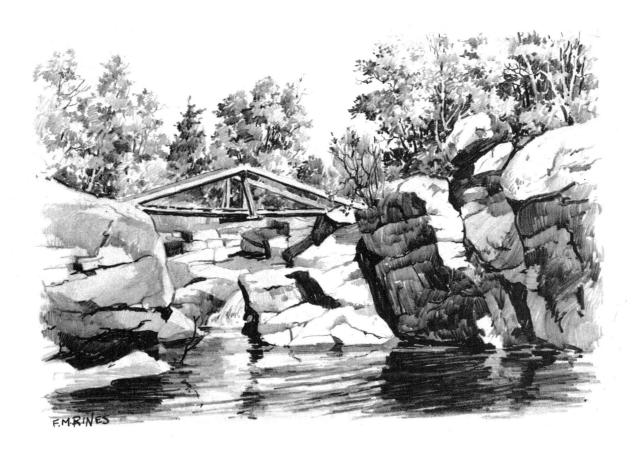

It is this contrast of both light and shade that makes a picture interesting.

F.M. RIVES

A PASTORAL SCENE

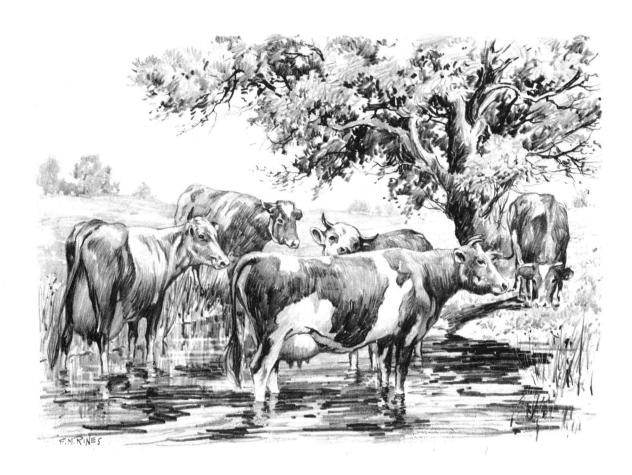

It may seem that too much importance is attached to such apparently minor things as the twig of a tree and its position. But it is these seemingly trivial things which, when the picture is viewed as a whole, are so subordinate, that make the final result successful or otherwise.

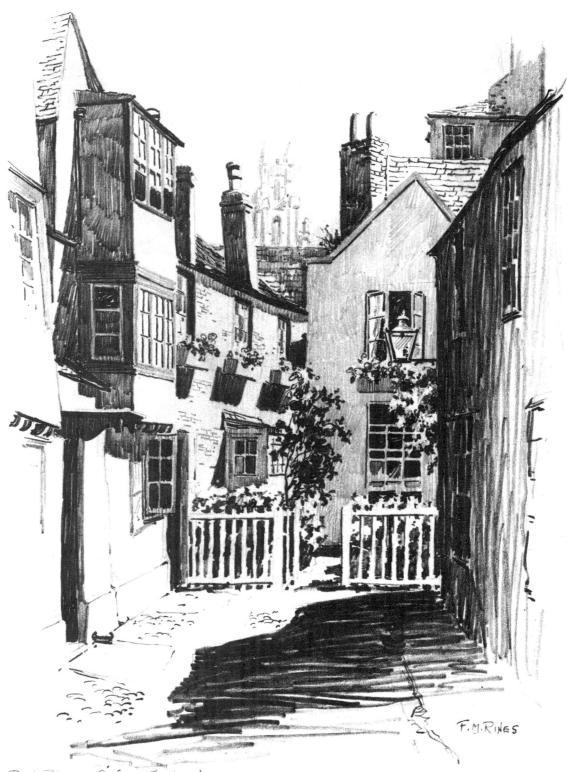

Bath Place Oxford, England,

BATH PLACE, OXFORD

The absolutely smooth texture of the plastered, gabled end of the building in the middle, admitted of but one treatment. The result is an excellent example of a smooth, flat grey pencil wash. Study it carefully, as well as the contrasting treatment of the building in front of it, on the right.

Observe how the whole drawing resolves itself practically into three tones, with the white paper of the building on the left forming one tone, that of the central building, already mentioned, forming the second, or intermediary tone, and that of the building on the right making the third, or darkest note. All the other values, with the exception of small areas of darker darks, used for accents, correspond to one of these three.

The tower in the background (one of the numerous college towers of Oxford) is drawn almost in outline, it being so distant, and unimportant to the rest of the composition.

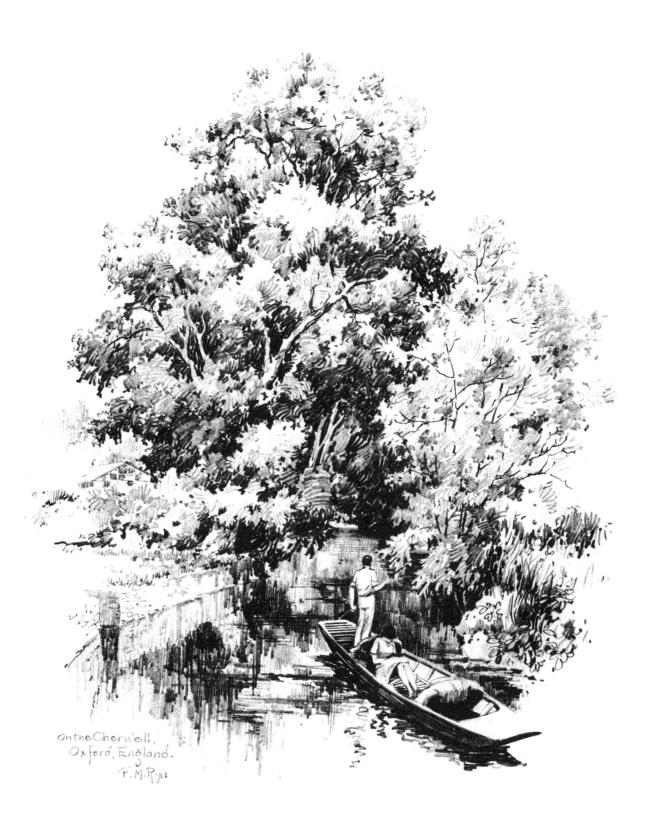

PUNTING ON THE CHERWELL

The manner in which the tree on the right of this picture (a young willow) has been made to stand in front, or come forward of the trees on the opposite river bank was the most difficult problem in making this sketch. It is always one of the most difficult matters to solve, and yet appears very frequently.

The more distant foliage was drawn first, and the dark tones brought up sharply against the solid outline of the willow, giving it the appearance of having been cut out from a piece of wood, with a jig saw. After this was done, the character of the silhouette was studied more carefully, working the darks into the white outline, taking care to get a variety of shape and spotting. Finally, washes of grey were applied to some of the foliage masses, in order to soften them.

Notice particularly how the strokes have been made on the larger tree, to bring out the different masses, or tufts of foliage, in direct contrast to the smaller tree, which being young growth, is naturally quite flat, in comparison. The branches showing through the foliage help to relieve what would otherwise become too much of a solid mass.

Study carefully the difference between the stroke used for the water and the trees.

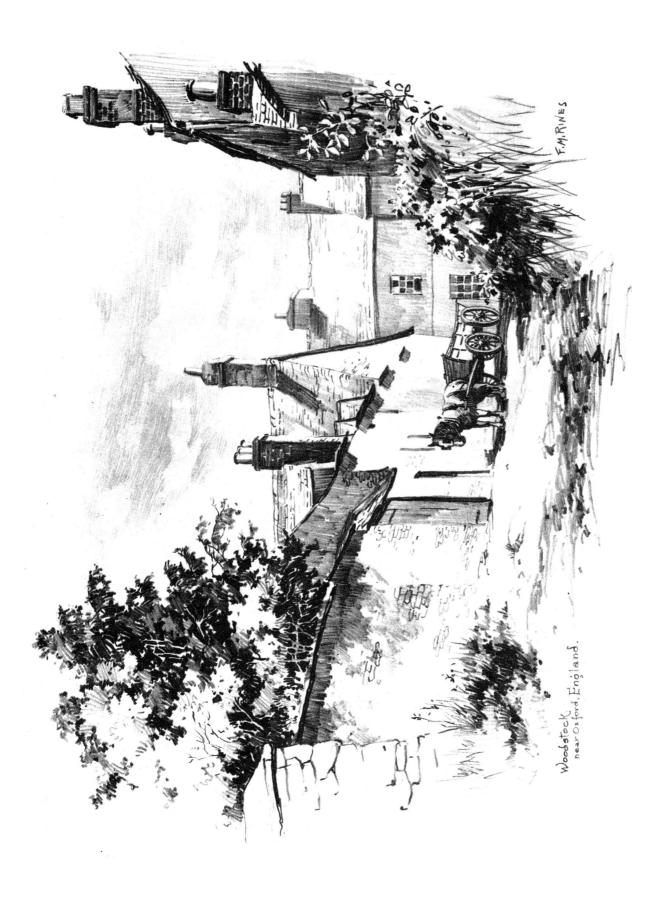

LANE IN WOODSTOCK

The problem in making this sketch was to have the eye wander down the lane, without becoming sidetracked along the way. The greatest difficulty was to avoid making two pictures; that is, having either side interesting in itself with nothing to connect them. This problem occurs very frequently and will be found in several of the other sketches reproduced here.

The dark tones on the path in the foreground and the grass strokes on the left, combined with the shadow in the middle distance where the horse and cart stand, as well as the horse and cart themselves, all serve to carry out the connection between the two sides. Even the clouds in the sky help to tie the picture together, as well as to break up the otherwise white paper which would compete too strongly with the sunlit white walls of the buildings.

Note how the shadow side of the chimney directly over the horse's head is much darker than the higher one, beyond.

This is done in order to bring the darker one nearer, and as the farther ones are lighter still, they recede even more.

The foliage on the left offers a good example of leaving white masses in the trees.

Especial attention is called to the shrubbery in the right foreground. Some of the separate leaves are actually drawn. This brings them in front of the buildings, thereby adding depth, or distance.

The walls under the trees on the left were built of white washed bricks, but it was necessary to suggest just a few of them. The bit of wall at the extreme left is left white and a few of the stones are drawn, their large size making it much nearer than the wall beyond it.

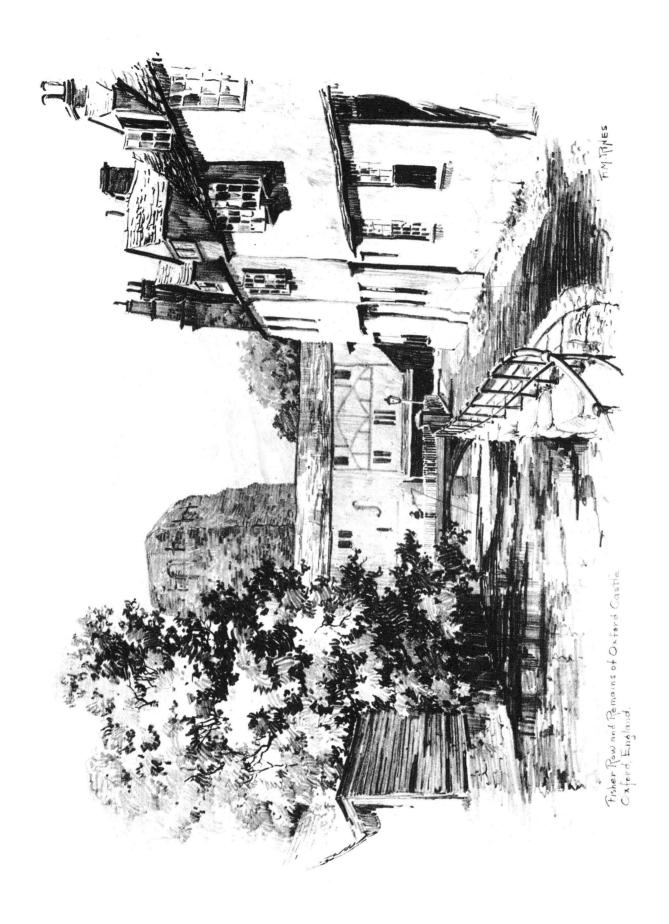

FISHER ROW AND OXFORD CASTLE

By far the most difficult part to render here was the tree. To avoid any straightness, or regularity of the silhouette required considerable planning, for the actual appearance was pretty much a straight line from top to bottom. Watch out for this in your own work; it is quite a common occurrence, and *must* be avoided.

The old tower, while quite grey in tone, has just enough of detail to show of what material it is constructed. The contrast between it and the buildings on the right, in brilliant sunshine, is quite evident.

Observe how the linear perspective of the iron railing and the tone of the sidewalk correspond; how the value of the walk lightens as it recedes, in harmony with the convergence of the rails.

The blackness of the doorway on the extreme right might appear inconsistent, but a dark spot there is very necessary as a balance to the amount of dark in the foliage and water opposite.

Often times this is the case, and one must be constantly watchful that his composition does not have an unbalanced, or one-sided feeling.

The suggestion of movement or current is evident in the water, in distinct contrast to the stillness expressed in some of the other water scenes.

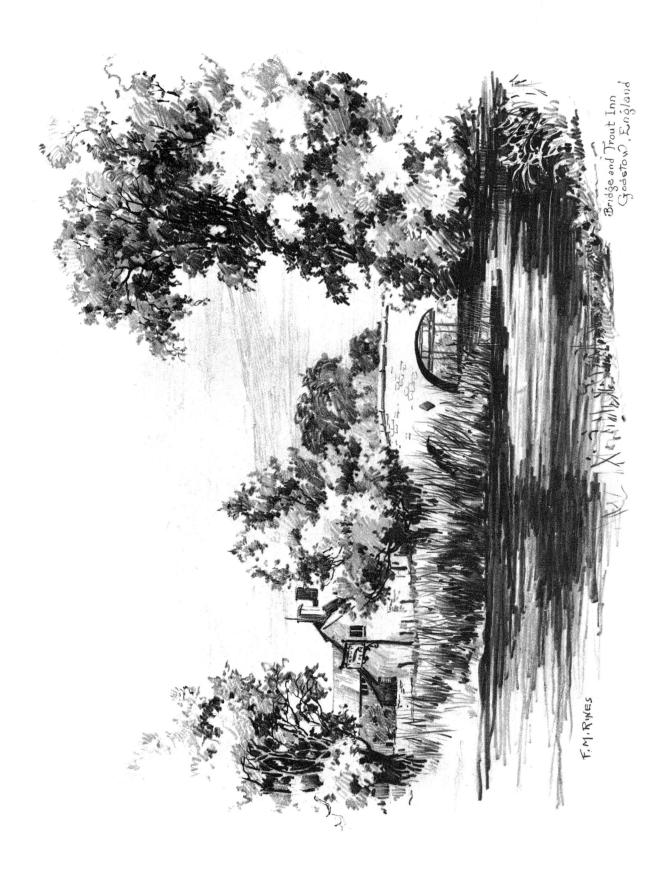

BRIDGE AT GODSTOW

Very much the same condition existed in the trees on the right of this scene as that explained at some length in the Punting Scene on the Cherwell. In this case, however, the light mass of foliage, being of a much older and denser growth than that in the other sketch, the masses have been emphasized and for the sake of contrast the farther trees have been thrown more into shadow and therefore appear more simple.

A noteworthy feature here is a demonstration of how the strokes are governed by the material being represented, i. e. the long grass, or reeds in the middle.

The bridge has been left practically white, but it is emphasized because it is so surrounded by dark tones.

Compare the water in this picture with that shown in some of the other sketches. The reason for its blackness is to add strength to the lower part of the composition. This weight is needed to balance the rather large proportion of sky space, and to offset the effect of what would otherwise appear as too much weight in the horizontal middle ground.

Its blackness also provides the opportunity for snapping out a bit the detail of grass in the lower right hand corner; just enough to bring the river bank nearer.

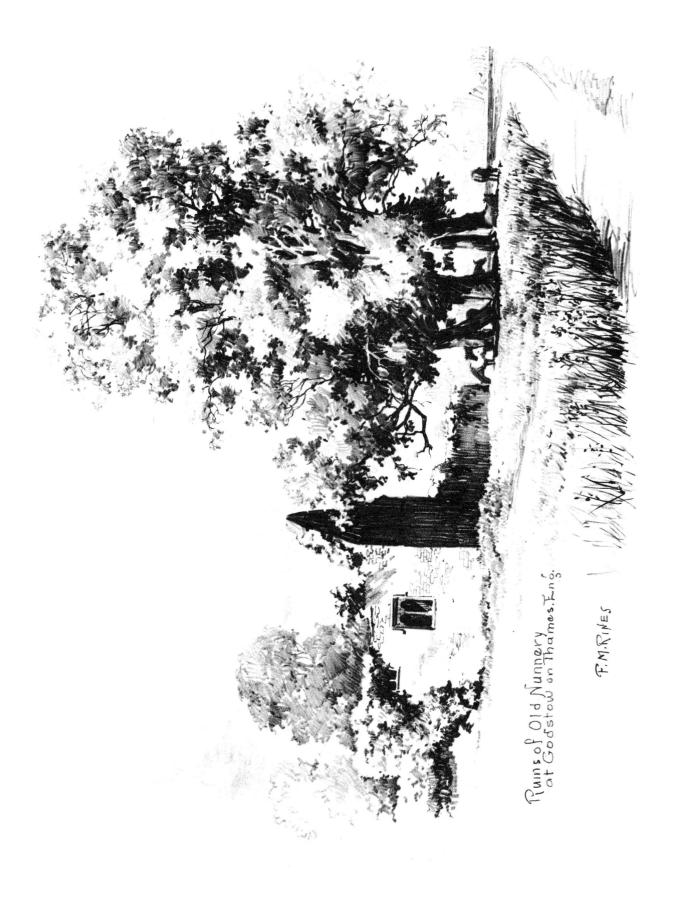

RUINS OF AN OLD NUNNERY

Among the several features in this drawing particularly worthy of study, the outstanding one is the group of trees. This was really the chief reason for making this subject; the ruins play a secondary part in the matter of interest. Note the design of the massing of sunlight and shadow in the foliage; also the lace-like quality of the edges as compared with the solidity of the central portion. While at first glance there appear to be but three trunks supporting this foliage mass, closer inspection will reveal five. In either case, three or five, they conform to the odd number grouping, spoken of elsewhere.

The trees in the background are almost poster-like in treatment, to contrast with the finer, suggested detail effect of the main group, while the actual detail in the long grass in the foreground brings this portion forward, a condition which must always exist if the drawing is to approach the appearance of the actual scene.

A few strokes to indicate clouds are needed in the upper lefthand section; otherwise too large an area of white paper would be shown, tending to counteract the white spaces so essential in other parts.

The blank space in the lower right corner is a tow-path along the river bank, although the water itself is not shown except for just a bit of grey tone in the distance.

The cows, grazing in the shadows of the trees, keep the scene from becoming too desolate.

Incidently, Fair Rosamond, the heroine of Sir Walter Scott's novel "Woodstock" is supposed to have been buried, in 1177, within the walls of this Nunnery.

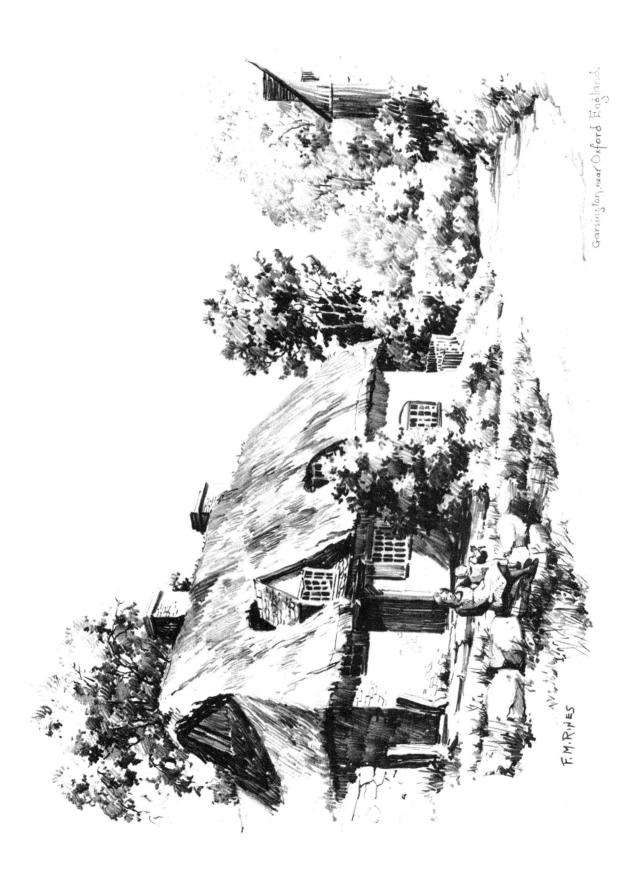

THATCHED COTTAGE, GARSINGTON

In this sketch the thatched cottage was the main object of interest, yet the country roadway was interesting, too. Cover up the right hand side of the picture and it will be seen that the cottage alone would hardly be of sufficient interest to warrant sketching.

In order not to detract too much from the house, however, the roadway was left almost entirely white paper and the more distant foliage was thrown into tone, in order to contrast with the detail of the cottage itself.

Notice the direction of the strokes on the roof. They conform to the texture of the thatch.

The nearer corner of the roof is snapped out white against the dark tones of the tree behind it, while the farther corner is a grey tone against the white paper of the sky. Doing this adds to the rather violent perspective line of the roof, helping to make the farther end of the building recede.

For the same reason, just a suggestion of brickwork, which showed here and there throughout the plastered sides, has been shown at the nearer corner.

Note the dormer windows with their slate shingles, and the way in which the thatch has been cut away around them. This gives a picturesque touch and makes the cottage different from many of the others seen thereabouts.

The figure in the foreground adds a human touch to the scene, keeping it from appearing deserted.

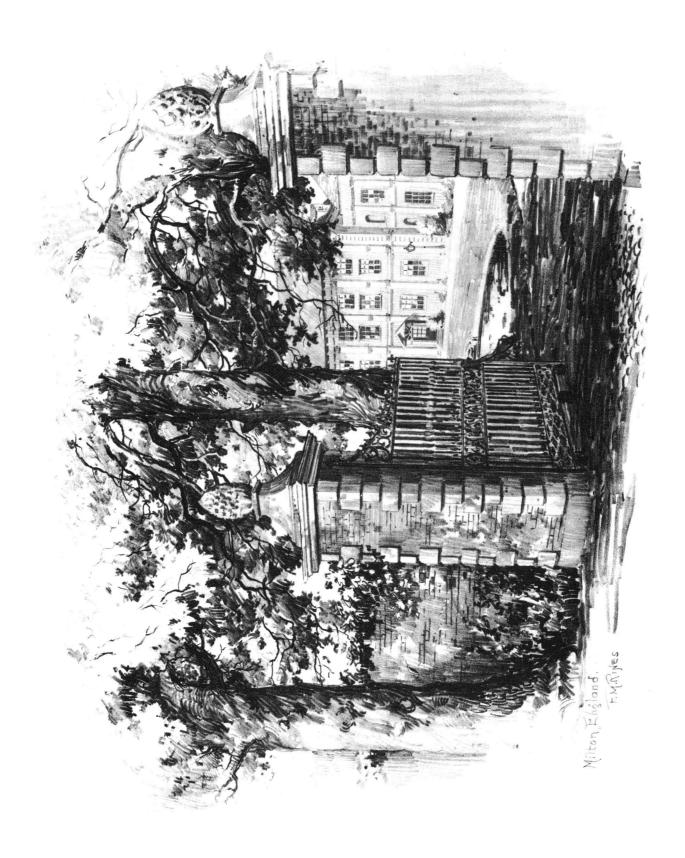

GRANGE GATE, MILTON, ENGLAND

The softer pencils were used for the dark green of the foliage and the brickwork, and shadows; for everything, in fact, except the house and bit of lawn in front of it. The H and 2H were used on these.

Doing this put the house in the background, or on another plane than the foreground, making a vista effect through the gate posts and trees.

Notice how a bit of the foliage and a dead twig have been drawn so as to cut the house. The contrast of these dark notes with the silvery tones behind them, creates "atmosphere" or space between them.

The shadow cast in the foreground by the trees adds greatly to the vista.

Particular attention is called to the pencil strokes on the tree trunks, denoting roundness and also, to the variety of strokes in the foliage. The branches and twigs emphasize how important it is to know "Tree Anatomy" and to apply such knowledge.

This drawing affords an unusually good opportunity to study the difference in handling between the architectural and the natural textures, as well as one of the most difficult problems to be met with in pencil sketching: the "vignetting" of the edges.

Although the subject of this sketch happened to be in England, it is very much like many to be found throughout the eastern part of the United States.

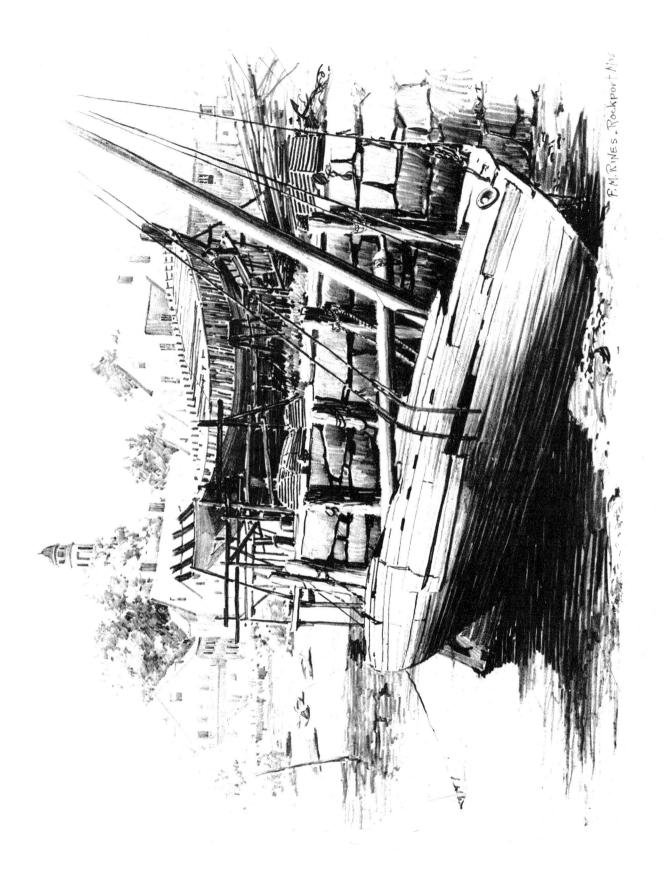

THE OLD AND THE NEW

The enormous amount of detail in this scene has been simplified as much as possible, but many different textures are still represented. The houses in the background are suggested with one tone and the white paper. The ship, under process of construction, is of a considerably darker tone than that used for the buildings, with just a bit of detail suggested here and there.

The old stone dock and its supporting piles, and the old boat, contain a good deal of detail.

Those three stages, or steps; the old boat and stonework, the new ship, and the houses, connected by the intermediate steps, such as the small boats on the beach, the water reflections, the lobster pots, lumber, etc., combine to give the appearance of distance, spoken of frequently in many of the other drawings.

The long, sweeping strokes on the hull of the boat in the foreground are in decided contrast to the short, rather choppy strokes of the water reflections, the stonework and the distant foliage.

The church tower, typical of so many New England towns, together with the solidity of the stone dock, the progress implied by the new ship being built, and the decaying hulk in the foreground, tend to give a romantic feeling in this picture; a result not always easily obtainable.

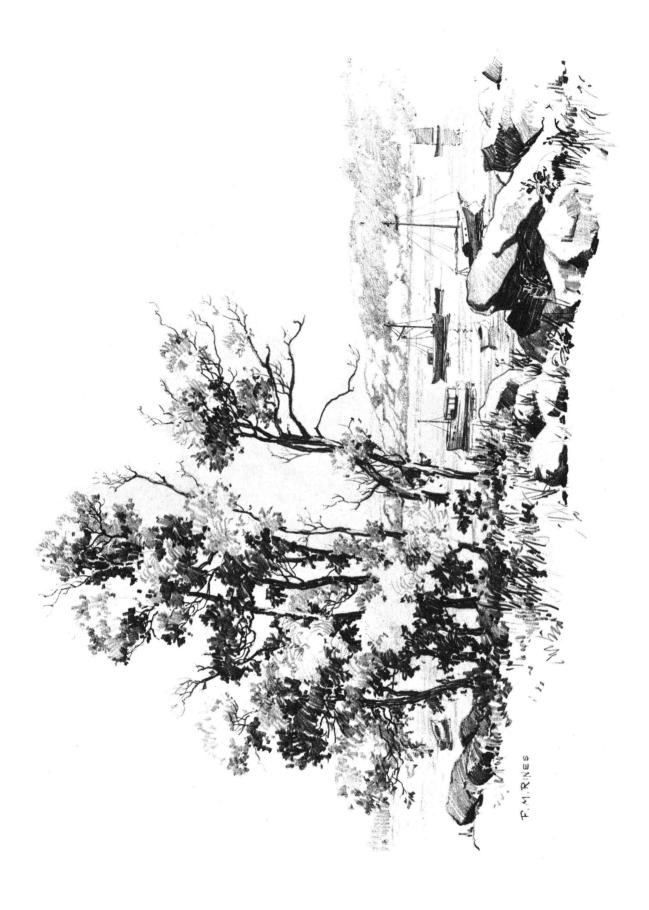

THE WILLOWS

A good example of the decorative quality of foliage is shown in this sketch. While, as previously stated, the design of the trees, as well as all the other elements of the composition should be given great attention, some subjects afford better opportunities than others for emphasizing this feature. The large amount of trunks and branches in proportion to the foliage, so characteristic of trees near the sea-shore which are forced to bear the brunt of much stormy weather, helps this decorative effect greatly.

The opposite shore is represented by flat grey washes, with patches of the white paper to indicate where the rugged and barren granite ledges crop out.

This same ruggedness, in much more detail, is suggested by the hard lines and sharp edges of the boulders in the foreground.

The last objects drawn in when making this sketch were the boats, as their values had to be gauged in relation to the tones of the background and foreground in order for them to assume their proper distance. Although the boats shown were only a few of the many appearing in the actual scene, note their variety, both as to positions and types.

Compare the large amount of white paper and "airiness" of this scene, with, for instance, that entitled "The Old and the New." This shows how one's subject should influence the treatment or handling of the sketch.

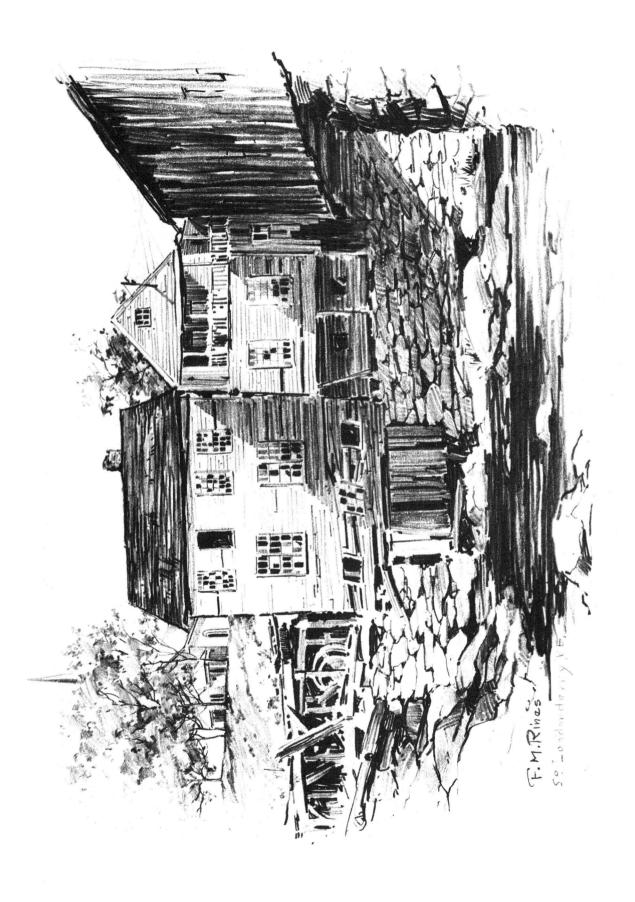

OLD MILL IN LONDONDERRY, VERMONT

The heavy tone on the extreme right, necessitated by the shadows on the covered bridge, is balanced by the snappy blacks and whites under the ruined platform on the left. Just enough black is contained in the broken dam, under this platform, to tie it up, or connect it, with the larger area of dark tones forming the shadows on and under the buildings.

The blackness of the 4B pencil in the water, brings it forward, as well as giving weight to the base of the picture.

The typical New England Village church in the background is an interesting subject in itself; therefore, great care must be taken that it does not form a second interest.

The shadow on the wall was made by drawing the stonework first in white with the heavy accents and then running the shadow tone over it.

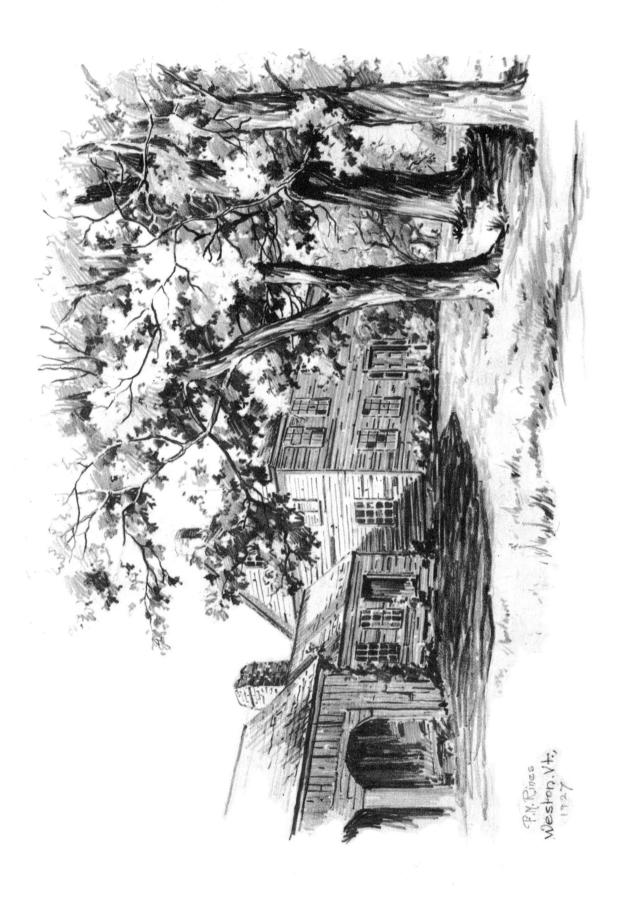

OLD CHASE HOMESTEAD

Notice how the *texture* of the weatherbeaten clapboards is brought out by the pencil strokes. Plenty of white paper is left between the strokes in order to give the shadow a luminous effect; in other words, to show the reflected light from the grass and foliage in front.

Compare the clapboard strokes with those used on the tree trunks, which are more on the curved order, to suggest the contour.

The dark branch of the tree which cuts the gable end of the house, helps to throw the building back. The large mass of white foliage brings it out in front of the other trees, keeping them from appearing too flat.

The white paper used to represent other masses of foliage, also carries out the effect of strong sunlight so apparent in the light and shadow on the house.

Particular attention was paid to the drawing of the tree trunks, the middle one being at a different angle, in order to provide variety or contrast.

Notice that the cast shadows, that is, the shadows cast by the ell on the end of the house, and the shadows of the house on the ground, are darker in value than the direct shadows on the sides of the house. This is a good rule to bear in mind: that the cast shadows are always darker, the reason being that they do not catch any reflections.

So much tone, or weight has been used on the house and the foliage, that very few strokes are needed to just suggest the grass in the foreground: the same problem of contrast once more.

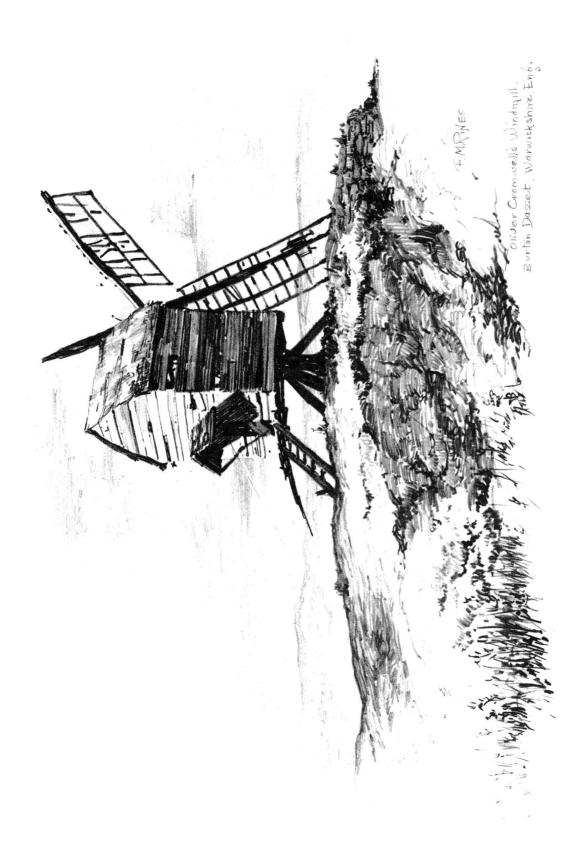

OLIVER CROMWELL'S MILL

The most impressive aspect of this subject, as viewed in nature, aside from the interesting features of the mill itself, was its setting of loneliness and isolation. With this in mind, a position well below the floor level of the structure was chosen from which to sketch it. This allowed for plenty of sky space in the picture, and the clouds, the flat silver greys of the distant hills, and the broken and uneven foreground all tend to emphasize this feeling of desertion.

On the shadow side of the building, the *color*, as well as the light and shade has been indicated. A special study of the clouds and foreground is urged. Since the subject of the picture, the mill, is so comparatively simple and lacking in detail, more work is needed in the foreground, a condition exactly the reverse of that met with in many of the other sketches shown here. For instance, compare the focus of interest of this subject with that of the row of half timbered houses at Chiddingstone, where almost no foreground has been indicated.

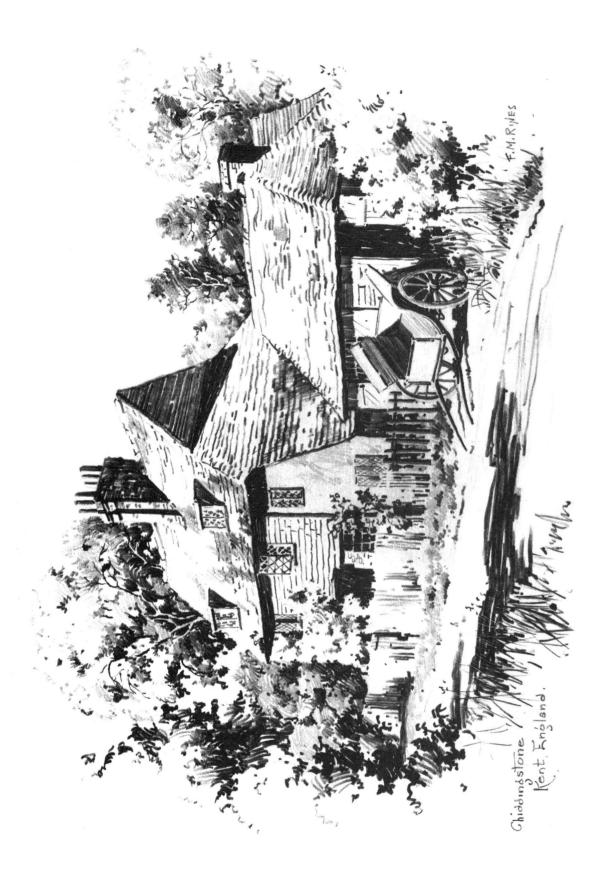

A CHIDDINGSTONE COTTAGE

Compare this drawing with the Thatched Roofed Cottage at Garsington. Aside from the different architectural features, the two problems might be construed to be the same. And so, to a certain extent they are, inasmuch as both contain about the same subject matter; a house, some foliage, and a roadway. But this picture might almost be entitled "A Portrait of a House," while the other is obviously a scene. The difference is that this house, possessing so much more architectural detail than the other has been centred more, making the background and foreground more subordinate. That does not mean, however, that they should be neglected. Just as much care has been taken with what might be called the "accessories" in this sketch as in the more prominent trees, grass, etc., of any other, only they have been simplified a little more.

Notice how the roofs (all tile) have been handled in order to avoid a monotonous effect. Note also how that part of the wall of the cottage which is of plaster has been drawn so as to contrast with that which is of wood.

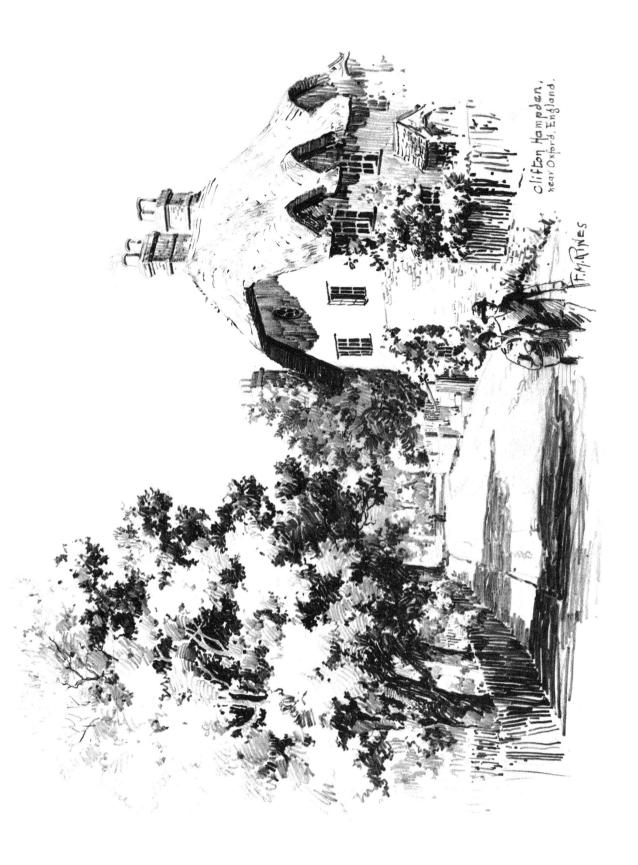

COTTAGE AT CLIFTON HAMPDEN

A peculiar feature of the thatched cottage in this scene needs a word of explanation. The end and side pictured were not at right angles to each other, hence the peculiar perspective. Aside from this peculiarity, there are several other interesting details; the way, for instance, the upper portion is of plaster and the lower half is of brick construction; also the different angles at which the two chimneys face.

The way the tufts of foliage catch the sunlight, causing great contrast between them and the holes, in deep shadow, makes a group of trees as interesting as the house itself.

When such a case occurs, as it does quite frequently, great caution must be taken to avoid a "two-in-one" effect. The shadows across the roadway, just touching the two figures, which in turn cut the base of the cottage, the light grey massing of the foliage in the background, and even the direction of the wispy smoke, all tend to pull the composition together and make one picture of it.

Note the difference in value between the shadows of the trees in the road. Although to the eye their difference, in reality, was so slight as to be indistinguishable, they must be drawn as they appear here; otherwise the ground would appear vertical instead of flat, or level.

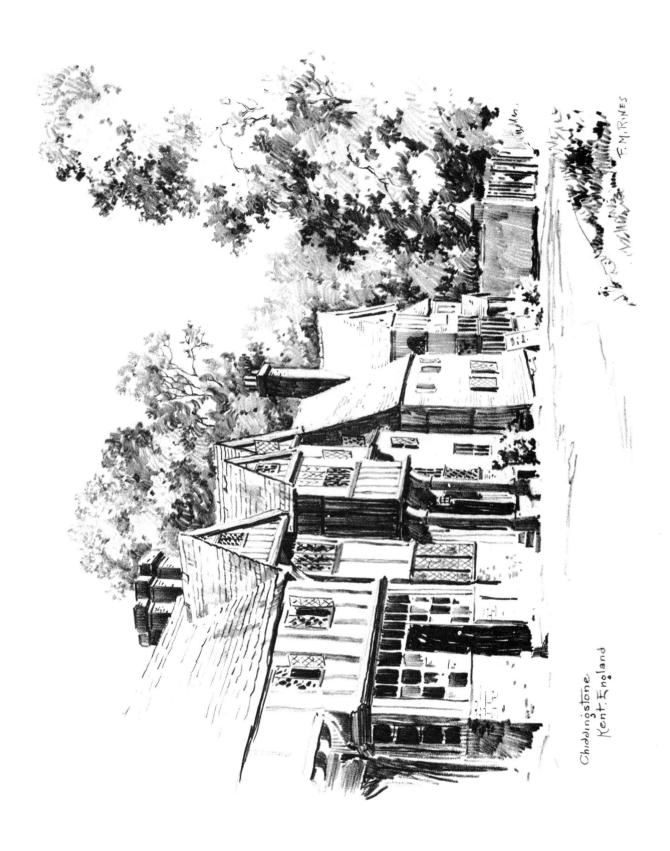

HALF TIMBERED HOUSES IN KENT

This long row of buildings, with the massed foliage behind them, is interesting on account of its variety of architectural detail. Even the three gables near the middle of the row are different in proportion and height.

Notice the snappy blacks in the doorway and window panes of the nearer house and the comparatively lighter tones of those in the distance. As in the other drawings reproduced here, this is done in order to obtain the perspective or receding appearance.

See how the lights of glass in the shop windows in the foreground have been broken up by making them different tones. This does not necessarily indicate broken glass, but shows, as so often occurs, the reflections, either of the clouds or foliage, and prevents the mechanical look which would otherwise exist. The same idea has been carried out, to a lesser degree. in the small latticed windows.

A suggestion of the slate shingles on the light roofs is all that is needed, for the foliage and the shadows of the nest of chimneys bring out the broken up roof lines sufficiently.

The vignetting of the tree on the one hand and the house on the other prevents a harsh line on either side.

Practically no foreground is needed here, as in several of the other sketches, for reasons already explained.

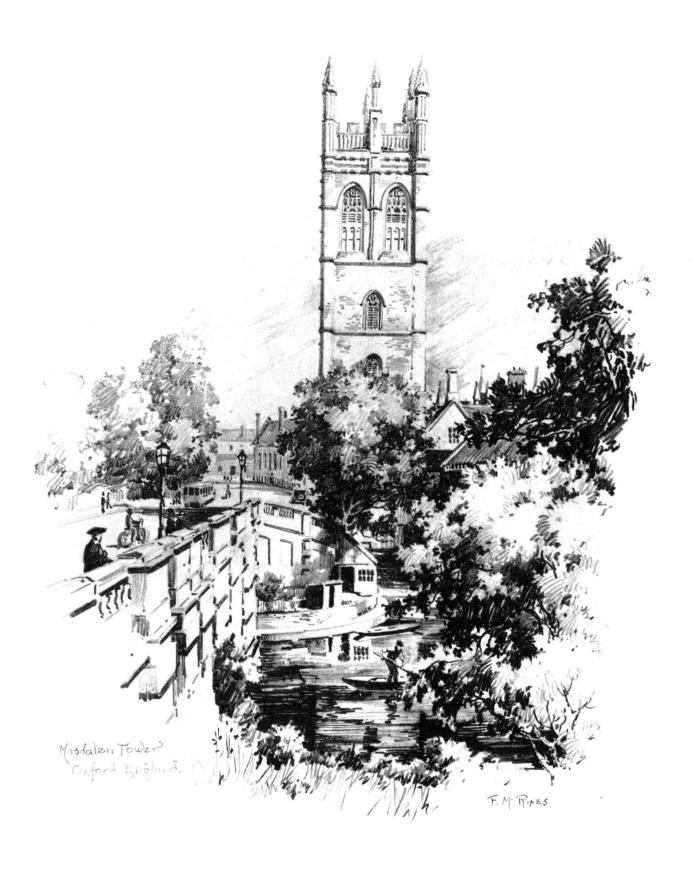

MAGDALEN TOWER, OXFORD

Observe that the tower has been placed just the least bit removed from the middle of the composition. To avoid a harshness of line, and to give it its real appearance of softness against the sky, the light clouds have been used to form part of the right hand edge, and where no clouds have been shown the white paper of the tower has been allowed to merge into the white paper of the sky. The horizontal lines stopping abruptly, as they do in conjunction with the clouds, complete the appearance of an edge, which is all that is necessary.

The different tones of the foliage, as it appears in its several different planes, might be described as a series of steps. The tree immediately in front of the base of the tower appears nearer than the trees across the street, on the left, by reason of its darker tones. While both the trees on the right are on the nearer river bank, the lower one, by reason of the white paper left in it, comes in front of the darker, higher one, which in turn, on account of its darkness and coarser handling comes much nearer than the one on the opposite bank.

For the same reasons, the reflections in the water, and the contrasting white of the shrubbery on the bank, have been drawn. In contrast to all of this, are the light grey tones of the buildings up the street, beyond the tower.

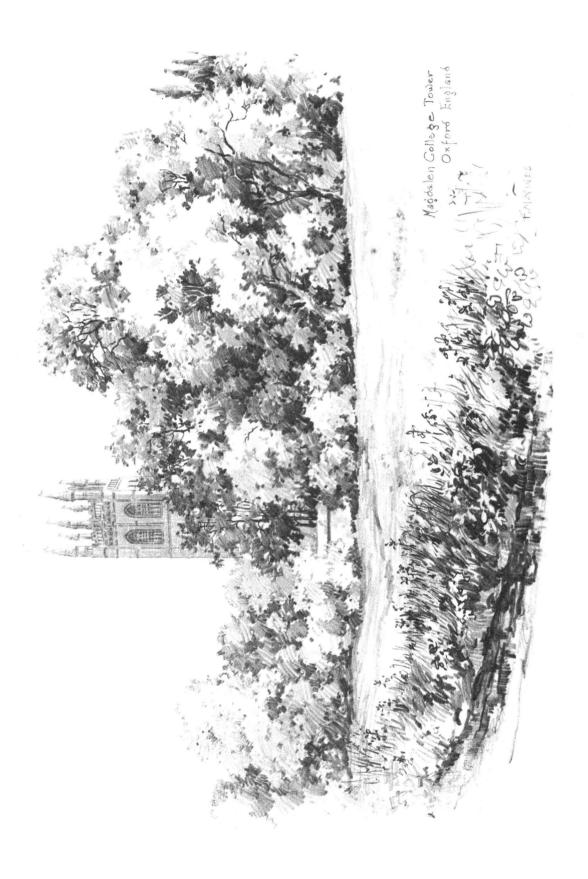

MAGDALEN TOWER FROM THE MEADOW

A conscientious study of the masses of white paper in the foliage of this scene is urged. By leaving a generous amount of these white masses, both sunlight, and a sense of three dimensions; i. e., depth, as well as height and length, has been obtained. These effects are impossible to produce otherwise. As in every case, the white areas stood out very sharp and definite at first; the grey tones, or modelling were added later.

A few leaves in detail, among the growth along the bank of the stream in the foreground, make them appear very close, in contrast to the entire lack of any such detail in the trees.

A few broad strokes of the pencil have sufficed to indicate the uneven contour of the meadow land.

The tower is of interest on account of its silhouette, rather than detail, hence the flat wash treatment, with a slightly deeper tone for the windows.

A subject of this nature, with its preponderance of foliage is much more difficult to render than those in which architecture, in one of its various forms, predominates. For that very reason, such subjects should not be avoided, but attempted over and over again, until gradually, they can be made with as much facility as the others.

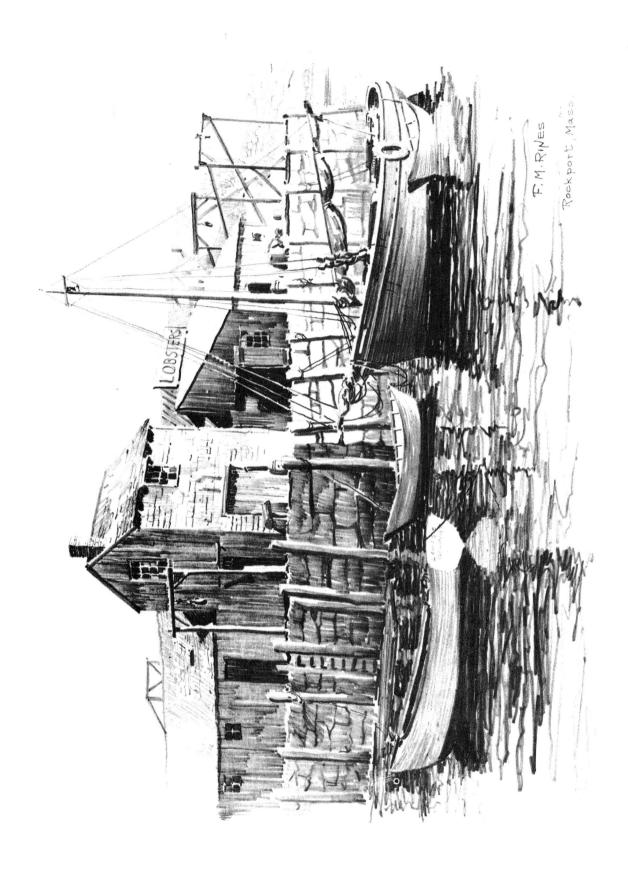

THE FISH WHARVES, ROCKPORT

To those who are fortunate enough to live along the New England seacoast, or to have access to it during the summer months, no other subjects are better adapted to pencil treatment than those similar to the one shown here, i. e., old fish houses, docks, and boats, together with the accessories always to be found in such an environment. The textures of the shanties, usually either unpainted weather-beaten boards or shingles, lend themselves unusually well to the quality of tones which the pencil produces, and so to quite an extent, do the rocks, piers, boats, water, lobster pots, etc.

Notice the difference in value between the reflections and the objects themselves. Observation will confirm the fact that reflections, no matter how clear, are darker in tone than the objects casting them.

Like the boats in "The Willows" scene, the placing of those in this sketch have been very carefully planned. This planning necessitated the elimination of some actually there, and the introduction of one or more of those nearby, in order to provide variety.

FLORAL TECHNIQUE

Subjects such as these are often available and offer excellent opportunities to practise drawing and technique.

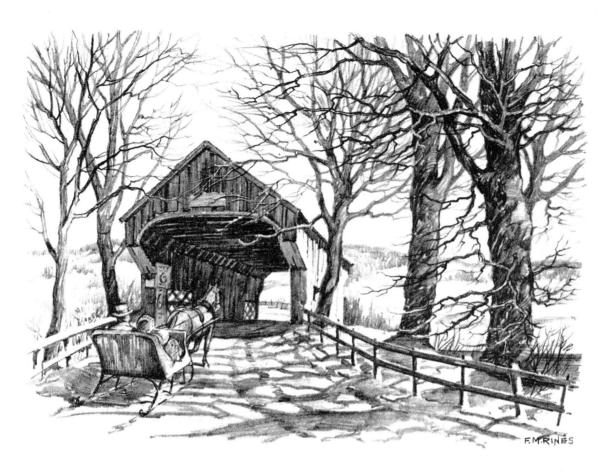

INDEX

Apple tree, 44, 45 Beech tree, 48 Birch tree, 46, 47 Bridges, 65, 67, 81 Brook, 59 Contrast, 13 of light and shade, 31 Cottages, 57, 85, 99, 101 Covered bridge, 65, 67 Edges, 12 Elm tree, 39, 40, 61, 63 Erasers, 8 Fixing, 13 Flowers, 110-111 Focal point, 16 Foliage, 37, 59 Houses, 70, 73, 94, 99, 101, 103 Light and shade, 31, 51, 69 Maple tree, 41, 61 Number of objects, 16 Oak tree, 42, 61 Paper, 7-8 Pastoral scene, 71 Pencils points, 8 types, 8

Perspective, 26 Photographed subjects, 22 Pine tree, 49 Poplar tree, 55 Preserving, 13, 15 Rocks, 53 Shade and light, 31, 51, 69 Shadow, 51 Silver poplar tree, 55 Street scene, 63 Strokes of pencil direction and character, 11 examples, 9-10 Sunlight and shadow, 51 Texture, 18, 28 Tree construction, 33-49, 59, 61, 75 anatomy, 34 edges, 35 limbs, 53, 57 Twigs, 55 Vines, 57 White oak tree, 42 Willow tree, 43, 53, 91